JEAN-PIERRE RAYNAUD

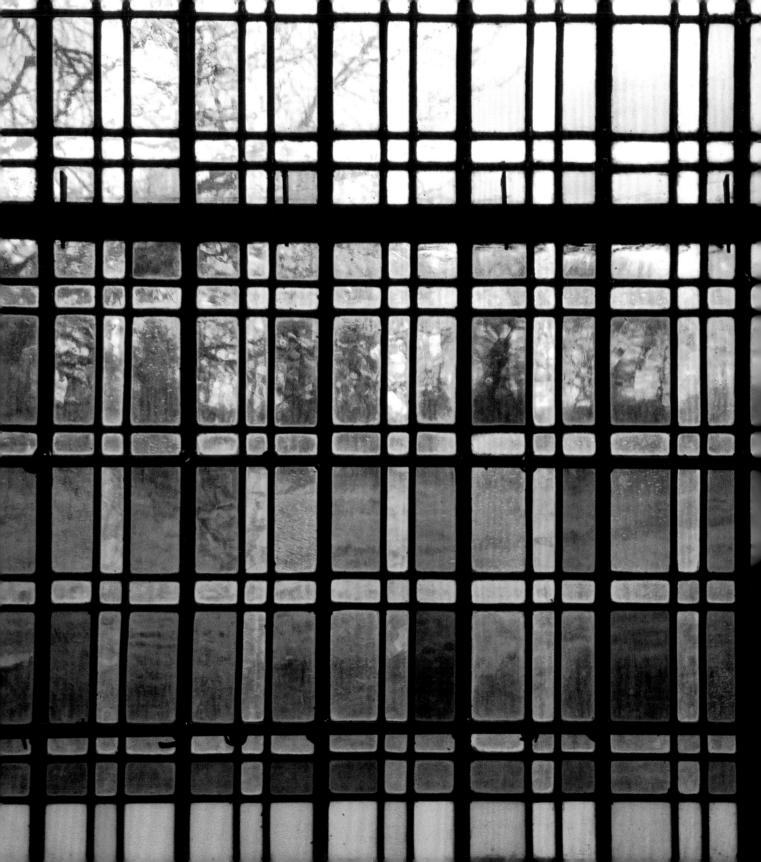

JEAN-PIERRE RAYNAUD

An Exhibition Organized by

l'Association Française d'Action Artistique

Texts by

Walter Hopps

Alfred Pacquement

Jean-Luc Daval

THE MENIL COLLECTION

The exhibition "Jean-Pierre Raynaud," which takes place within the framework of official cultural exchanges between France, Canada, and the United States, was organized under the auspices of the following French government agencies:

the Ministry of Foreign Affairs, Office of the Secretary of State for International Cultural Relations;

the Ministry of Culture, Communications, and Major Projects;

by l'Association Française d'Action Artistique.

The exhibition was curated by Alfred Pacquement, Director of the Galerie Nationale du Jeu de Paume.

Exhibition Itinerary

The Menil Collection, Houston
January 25 – March 10, 1991

The Museum of Contemporary Art – Chicago
April 6 – June 9, 1991

Centre international d'art contemporain de Montréal
September 4 – November 3, 1991

Cover: Raynaud, *Décomposition,* 1989.

Frontispiece: Raynaud, Noirlac Abbey refectory window (detail), 1976.

Library of Congress Cataloging-in-Publication Data

Raynaud, Jean-Pierre, 1939–
 Jean-Pierre Raynaud.
 p. cm.
 Exhibition presented at The Menil Collection, Houston, Texas, Jan. 25–Mar. 10, 1991; subsequently at the Museum of Contemporary Art–Chicago, Apr. 6–Jun. 9, 1991, and the Centre international d'art contemporain de Montréal, Sept. 4–Nov. 3, 1991.
 Includes bibliographical references.
 ISBN 0-939594-23-4
 1. Raynaud, Jean-Pierre. 1939—Exhibitions.
 I. Menil Collection (Houston, Tex.).
 II. Museum of Contemporary Art–Chicago, Ill.
 III. Centre international d'art contemporain de Montréal
 IV. Title.
 N6853.R33A4 1991 709'.2–dc20 90-22772 CIP

Contents

Acknowledgments

This exhibition and catalogue would not have been possible without the exceptional assistance and enthusiasm of Jean-Pierre Raynaud. To him we owe our deepest appreciation.

To the institutions and private collectors who have lent to this exhibition, we wish to express our sincere gratitude. The quality of the exhibition owes a great deal to their generosity.

The project was conceived by Daniel Abadie at l'Association Française d'Action Artistique, under whose auspices it is presented in America. Our gratitude goes to M. Gérard Guyot, Special Adviser at l'Association Française d'Action Artistique (Plastic Arts Division), who was instrumental in its realization.

Special thanks are owed to Alfred Pacquement, recently appointed Director of the Galerie Nationale du Jeu de Paume, who has served as curator for the exhibition and is responsible for the selection of works and preparation of the catalogue texts, chronology, and bibliography. We are indebted to him and to Jean-Luc Daval for sharing their insights on the artist and his works in the essays they have contributed to the catalogue. We thank Walter Hopps for the exhibition's initial installation and for his introduction placing the artist's work in context for an American audience.

We are most grateful to Denyse Durand-Ruel for her enormous assistance in every aspect of the project from its inception, and in particular for providing access to information and photographic documentation on the artist in the Archives Denyse Durand-Ruel.

In France, Marie-Dominique Blondy, Pascale Vallin, and Françoise Bonnefoy have been essential to the organization of the exhibition.

Kevin Consey, Director, and Bruce Guenther, Curator, generously welcomed the proposal to share the exhibition with the Museum of Contemporary Art–Chicago. Its presentation in Montreal has been made possible through the enthusiastic interest of Claude Gosselin, Director, Centre international d'art contemporain de Montréal.

In Houston, Dominique de Menil has given extraordinary support and encouragement to the project. We are grateful to Karen Chambers Dalton for her translation of the catalogue essays, and to Bertrand Davezac for his comments on the text. John Kaiser has been indispensable at every stage of the production of the catalogue.

We wish to thank The Menil Collection staff, in particular Julie Bakke and Deborah Brauer for their assistance with the exhibition, and Don Quaintance and Arvin C. Conrad for the design and production of the catalogue.

Paul Winkler, Acting Director
The Menil Collection

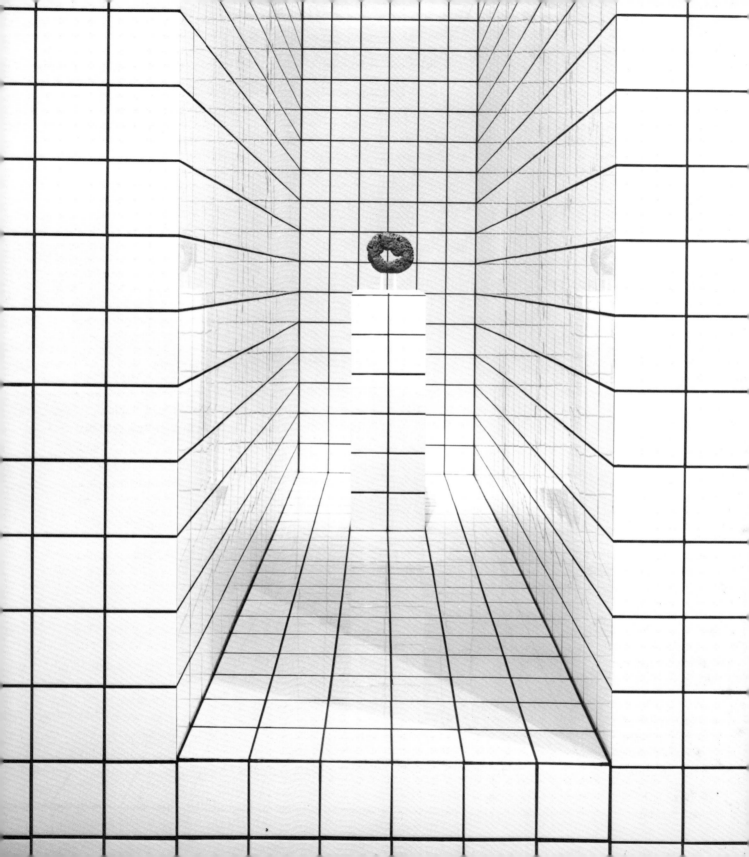

AN AMERICAN PERSPECTIVE

WALTER HOPPS

I first encountered the work of Jean-Pierre Raynaud around 1969 in the course of arranging an exhibition at the Corcoran Gallery in Washington, D.C. The exhibition featured work collected by Marc Moyens, a French national with an unusually sharp-eyed interest in contemporary art from both Europe and America. Moyens showed me photographs of examples of Raynaud's work, such as the *Psycho-Objets* [*Psycho-Objects*] and the *Jauge* [*Gauge*] series. This work was immediately compelling, striking in its directness and mystery. I was surprised to discover that Raynaud was virtually unknown in the U. S. It seems extraordinary that across the ensuing twenty years Raynaud's art has remained so little known and acknowledged in America. It was only with Paul Schimmel's prescient but unheralded exhibition of Raynaud in 1984 that this situation began to change.

From today's vantage point, Jean-Pierre Raynaud is arguably the most important artist to have emerged in France since the death of Yves Klein in 1962, an artist of major international significance.

It seems instructive to consider some of the reasons why Raynaud's recognition in this country has been so late in coming. At the outset we must recognize that, from the late 1950s through the 1960s, America's self-absorption with new American art was extreme. Although modernism's great European pioneers (Henri Matisse, Joan Miró, Piet Mondrian, and Pablo Picasso) previously had occupied center stage in America, the immediate postwar years saw little intellectual or institutional support for newer European art beyond that of Henry Moore and Francis Bacon from England or Jean Dubuffet and Alberto Giacometti in Paris. A noteworthy exception would be the late James Johnson Sweeney's presentations at the Guggenheim Museum of postwar European artists such as Roger Bissière, Alberto Burri, Asger Jorn, Georges Mathieu, Pierre Soulages, Nicolas de Staël, and Antoni Tàpies.

This midcentury "Triumph of the New American Art" has been declared, analyzed, and argued in great depth and at length. Nonetheless, it is historically crucial to emphasize that for many American artists such as Willem de Kooning, Barnett Newman, Jackson Pollock, Mark Rothko, Clyfford Still, et al.—who were certainly no longer *young* artists at midcentury—little commercial and virtually no sustaining institutional recognition of their work existed until the *late* 1950s.

An extraordinary and dramatic change took place around 1957 (following Pollock's death in August 1956). This resulted from a critical awakening, collector and museum acquisitions, and increased media prominence for these artists. A "logjam" phenomenon arose, as the 1960s began with a substantial backlog of art to be addressed on all intellectual and public fronts. Simultaneously, a vast new generation of American artists emerged, receiving startlingly rapid and widespread recognition. As a result, the high-volume breakthroughs of Jasper Johns, Robert Rauschenberg, Frank Stella, Andy Warhol, and their peers

1. *Espace zéro,* "La Rime et la Raison," niche with Yves Klein's blue sponge sculpture, c. 1961

further crowded the post-1960 art scene in America.

It now seems fair to say that from the later 1950s, America was preoccupied, and its venues saturated, with its own new art, to the exclusion of any number of vital developments in Western Europe and beyond. As this logjam cleared in the later 1970s, a new spirit of pluralism arose. Concurrently, young American artists exploring abroad began to champion works by their European peers. In this way, major European contemporaries of Rauschenberg and Johns—such as Joseph Beuys in Germany and Yves Klein *(fig. 1)* in France—began to attain their current high stature. A real measure of reciprocal interest (new European art coming to America) gathered momentum during the the 1980s, with the Germans and Italians largely leading the way.

Raynaud believes that his first important art dates from 1962, thus centering his emergence within the hyper-congested decade that I have just described. I would like to consider and compare Raynaud's art with that of two of his American contemporaries: Stella and Warhol. These two disparate artists (along with many others related to each) seemed, from the 1960s onward, powerfully to divide vanguard American art into two separate modes of activity. Stella and company were rigorously locked into non-objective, formalist abstraction, whereas Warhol and company were committed above all else to a starkly iconic presentation of literally rendered and recognizable images.

In America these two factions of "primary structures" on the one hand and Pop art on the other were not to mix for nearly twenty years. Raynaud's proclivity to intermingle (albeit within the canons of French modernism) aspects of formal abstraction and iconic imagery within a single work—a violation of this acknowledged separation—was quite enough to make his work suspect to many American critics during the 1960s and 1970s. However absurd it seems today, it was as though Raynaud were guilty, in the eyes of the American art world, of a kind of aesthetic miscegenation.

2. Frank Stella, *Avicenna,* 1960, aluminum paint on canvas, 69 x 69 in., The Menil Collection

In 1959 Stella, with his now-famous Black Paintings and Aluminum Paintings series, began one of the most rigorously systematic, serially generated bodies of work in twentieth-century art. First reactions to this work—views both sympathetic and appalled—found it to look manufactured, to have an industrial bluntness. I would suggest that a sense of this new "factured" painting-object, as touched upon in Stella's *Avicenna (fig. 2),* had indeed independently occurred with Raynaud as well, as early as his *Sens + Sens* of 1962 *(pl. 1).* However, Raynaud's delicate intimation of French decorative elegance (as on the top left edge of *Sens + Sens*) ran counter to American sensibilities for a more hard-edged severity.

By 1962 Warhol had become America's most controversial and decisive icon-maker of everyday images *(fig. 3),* and we find parallel activity in Raynaud's work, beginning at least with his Psycho-Collages of 1964 and the later Psycho-Objects. However, while Warhol employed an evolving and varied series of common images (from popular comics, advertising, and newspress photos), Raynaud obsessively featured perhaps no more than two photographic images of anonymous persons. In virtually every case, Warhol's images (whether soup can or celebrity) are specific, recognizable depictions that echo sources of early American realist art. In contrast, Raynaud's anonymous figures in uncertain settings evince a mysterious provocativeness and ambiguity that reprise French Symbolist traditions. Both Warhol and Raynaud repeat, from work to work, their own conventionalized images, either individually or in sets *(pls. 5, 6)* and varying in size from miniature to heroic *(fig. 19, pl. 12).*

Three essential strategies of working, relatively new to the 1960s, are practiced in common by Raynaud, Stella, and Warhol, along with many of their contemporaries. All three artists, despite their dissimilarities of imagery and aesthetic principles, nevertheless tend to *facture* work rather than to paint or to sculpt, thereby revealing little trace of the artist's hand or drawing style. Structurally, all three artists work with images or forms (whether non-

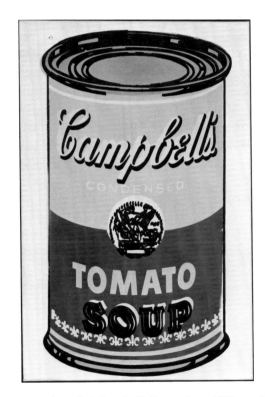

3. Andy Warhol, *Campbell's Tomato Soup,* 1963, acrylic and silkscreen ink on canvas , 20 1/8× 30 in., The Menil Collection

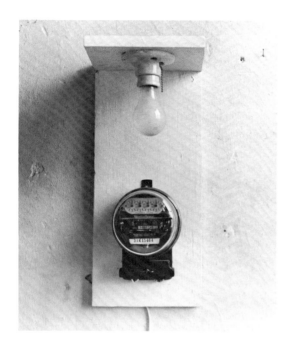

4. Robert Morris, *Metered Bulb*, 1963, light fixture, painted wood, and electric meter, 17³/4× 8 × 8¹/4 in., private collection

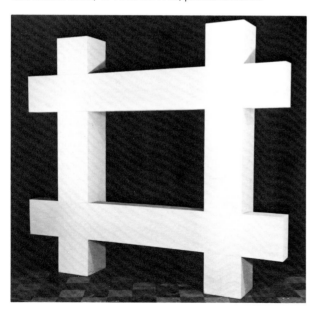

5. Robert Morris, *Barrier*, 1962, plywood and paint, 78 × 90 × 12 in., destroyed

objective or iconic) in a way that is rigorously frontal and rationally generated. Gridlike systems and serial repetition, whether within a work or in a series of related works, have been widely employed in important ways by all three.

The American artist of Raynaud's generation who, unlike Stella and Warhol, most conspicuously crosses stylistic boundaries and intermingles modes of working is Robert Morris. Over the course of his career, Morris has produced emphatically non-objective sculpture (the "primary structures" of the early 1960s *[fig. 5]*); imagist work with fully representational and often narrative elements, such as his *Metered Bulb (fig. 4)*; amorphous works celebrating materiality and process, such as his *Thread Waste* piece or his sited work *Steam,* which rises from the ground; and ceremonial architectural projects, such as his labyrinth or observatory of an imagined culture. Morris has probably gone through more disparate metamorphic changes in his art's forms and materials than has any artist of his time.

A counterpart metamorphic progress indeed characterizes the course of Raynaud's development as well. What is emphatically shared by the two is an open, generally eclectic approach to modes, materials, and forms, as well as the use of autobiographically narrative images. In their more recent work, mortality is an explicit concern: Morris' cenotaphs and memorials; Raynaud's imagery of medical emergency and crisis *(pls. 30, 31, 35)*.

Just prior to his untimely death in 1961, similar themes of memoriam and mortality were prefigured by Yves Klein in one of his last works, *The Tomb—Here Lies Space,* 1960, which also introduced certain other physical concerns that were to become crucial to important members of a generation of American artists twenty years later in the 1980s. To create *The Tomb,* Klein used one of his large gold monochrome paintings as a ground or plaque. He placed a bouquet of five pink artificial roses in one corner of the gold space, and in the diagonal corner he placed a wreath-like form (a sea sponge saturated with his

intense blue pigment).

This quite moving work was unique in Klein's oeuvre. While in New York in 1961, he described *The Tomb* to me as involving an investigation of what he termed "the metaphysics of the ordinary, the metaphysics of kitsch." Klein also spoke of his fascination with "the artificial" and "the artificiality of display," stating that *The Tomb*, which variously puzzled or annoyed his small New York audience, opened up for him a major area worth pursuing.

Clearly, it was Jean-Pierre Raynaud who came to absorb and understand the unique aspects of *The Tomb*. Virtually the entirety of Raynaud's production fuses issues of metaphysics and mortality with common and, indeed, often kitsch objects. Additionally, Raynaud strikingly expanded and broadly developed a quality of *focused and asserted presentationality* that is manifest in the Klein work. Although a celebration of pristine display was integral to Raynaud's work throughout the 1960s, by the 1970s this tendency became even more rarefied and pronounced in his extended serial work with white tile, such as his objects united with pedestals and vitrines *(pls. 27, 28)*, the Carrelage series *(pls. 17, 18)*, and above all, the monumental achievement of his *House (figs. 20–27)*.

The employment of an ensemble involving a base and/or enclosure as an *essential* part of a total art work and the concept of "presentedness" does, of course, occur throughout earlier modernist art. Complex ensembles happen early and notably with Constantin Brancusi and are utilized in critical ways by Marcel Duchamp. Klein's French contemporary Arman has made prolific use of containers and display techniques. Despite these historical precedents and ongoing activity, it is worth noting that a number of modernist critics, especially in America in the 1960s, were troubled by art that depended upon assertive "presentedness" or an esthetic aspect identified by Michael Fried as "theatricality."

Morris and Raynaud exist as major precursors of a vital art developing after 1979—the art identified as postmodernist. In America a significant number of diverse younger artists have aggressively combined formalist structure with imagist depiction, for example, Robert Longo in his hyper-melodramatic reliefs and sculpture. Haim Steinbach emphasizes integral aspects of presentation and pristine display in works where refined formalist constructions literally support both common and exotic objects, rigorously selected and exquisitely placed. The extreme celebration of objects universally seen as utter kitsch is recognized as a major part of Jeff Koons' work.

In the course of his ongoing research, Jean-Pierre Raynaud exists as one of our most important links between twentieth-century modernism, mourned and celebrated by him as an intensely personal experience, and the postmodernist aftermath. In confronting any number of controversial developments within today's art, we must acknowledge that Raynaud has been there all along, living his art, acute and resolute, advancing into our future to meet us on the edge of our current conceptual horizons.

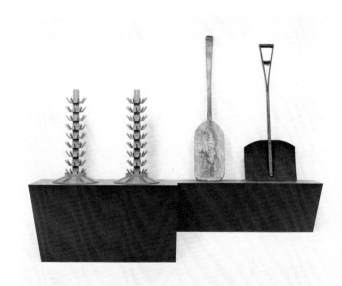

6. Haim Steinbach, *Fresh*, 1990, plastic bottleracks and shovels on laminated wooden shelf, 77³/4× 96¹/2× 23³/4 in., The Menil Collection

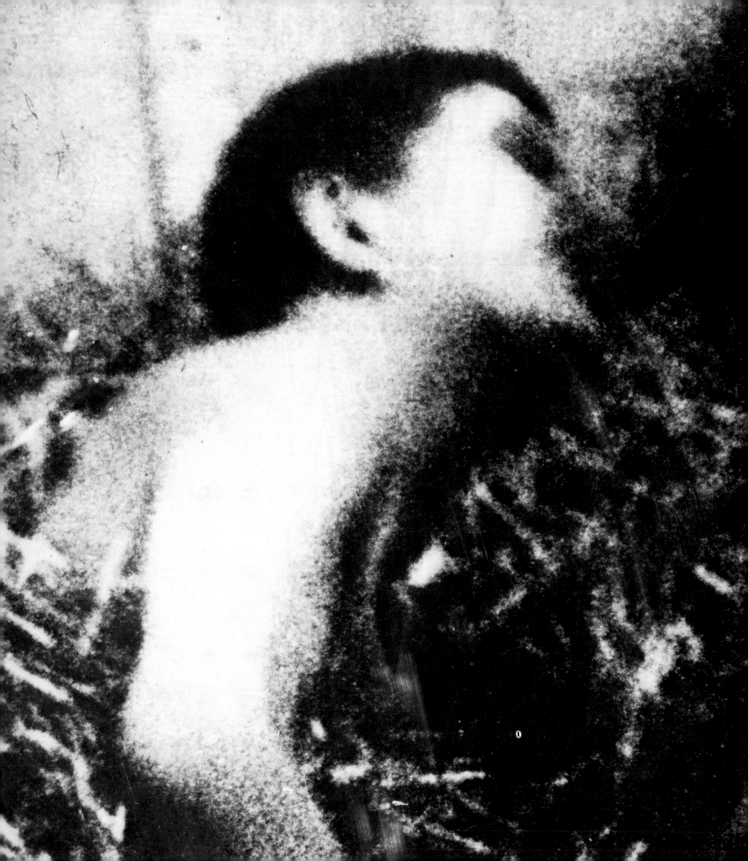

AN ART OF MEMORY

ALFRED PACQUEMENT

Modernity can be characterized as an attempt to bring together two contrary pursuits. One is the quest for individualism in the form of an original journey, of a vision unhampered by any constraints, in which the winds of creative freedom blow. The other pursuit may be unconscious initially, and it may include a certain urge to break with the past, but it is characterized by an attempt to draw upon a historical evolution and by a search to participate in a tradition. In this light, the art of Jean-Pierre Raynaud seems to be one of the most exemplarily modern created in Europe since the 1960s.

Supremely individualized and possessing an authentic introspection to which we will return time and again in this essay, Raynaud's art challenges that ruling neutrality found in contemporary formalism. However, the catalogue of forms he uses subtly brings back some of the most rigorous of the essential advances of twentieth-century art: we are referring, of course, to the Constructivist tradition, symbolized in Raynaud's work by the continuous repetition of a white square edged in black, by the limited use of pure color, and by the use of a few primary forms. But these predominant practices are related to other, more immediate ones, such as the reuse of everyday objects, following the New Realists and their predecessors, though in an altogether different spirit.

It is useful to note at the outset that Raynaud has frequently taken the risk of associating his work with that of earlier artists: recall his positioning Malevich's black cross at the back of a white ceramic container, or his hanging Matisse's drawing of sycamore leaves near a stela beside which lay a real leaf, delicate as though newly fallen. And there have also been objects from other periods and other civilizations that Raynaud has arranged in *Espaces zéros* [*Zero Spaces*], such as the one conceived for the entrance to ''La Rime et la Raison [Rhyme and Reason],'' the 1984 exhibition of the de Menil family collections in Paris. Slightly earlier, he brought a special intensity to his work at the Cistercian abbey of Noirlac: into this twelfth-century monument he introduced stained glass, grounded on the interlacing of perpendicular lines. Such encounters are not happenstance, but bespeak a rich, synthetic body of work, transcending the mundane and temporal: an art of memory.

Beginning with his earliest assemblages in 1962, Raynaud has built a complex oeuvre with a simplified vocabulary based on the manipulation and combination of a limited number of elements. This quasi-minimal reduction of his plastic language is justified by the intuitive, thoroughly visual choices of an artist who did not learn to paint and who has always insisted that he cannot draw, in the academic sense of the term. Raynaud seizes upon everyday objects, selecting from the urban landscape or from his cultural universe meaningful signs whose appearance he will emphasize or modify by placing them in revamped interiors and on tile stelae. The essential point amounts to the sort of immediate efficacy typical of

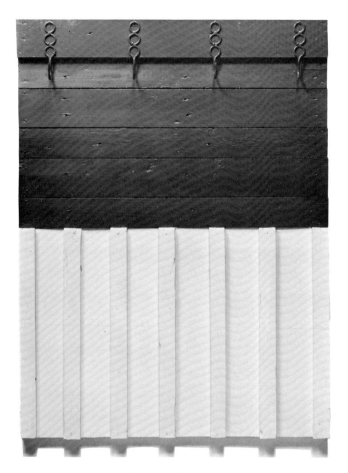

8. *Objet aux 4 crochets* [*Object with 4 Hooks*], 1962, painted wood and iron. 45 1/2 × 35 1/4 × 4 in., collection of the artist

To grasp fully this evolution, nothing is more enlightening than comparing earlier works with more recent works: this demonstrates how Raynaud, while consistently returning to certain themes or major motifs, introduces variants chosen to accentuate the essence of a combination of forms. At present, after almost three decades of work, such examples abound: for instance, a recent assemblage associating tilework and chrome hooks alludes to the *Objet aux 4 crochets* [*Object with 4 Hooks*] *(fig. 8)*, one of his fundamental works from the early 1960s; or another, featuring a bright red wheelchair, brings to mind, both because of the contrasting red and white and because of the choice of equipment associated with illness or hospitals, the family of *Psycho-Objets* [*Psycho-Objects*] from between 1964 and 1967; and so on. The loop comes full circle, expressing, as is common with artists, a kind of serene maturity, a kind of certainty. The purpose of each work is not to add a novel idea or impression, but rather to affirm a process and reinforce a pre-established plastic language. This does not exclude questioning or doubt, but it makes possible a calm, self-possessed development. Anyone who knows Raynaud can testify to his very particular way of putting forward the plan for a new project: the almost infallible solidity of the idea never gives way to the ever-renewed enthusiasm so often seen in a young artist rapt with the creative euphoria of his first completed undertakings.

To elucidate further these remarks, let us consider two somewhat atypical works. Both are small, calling to mind notes jotted down in the margins of larger compositions: their radical nature and symbolic tension say much for the ambitions of Raynaud's oeuvre.

. . . *Fragment*, 1974 *(pl. 21)*, a simple square of white ceramic with a ragged black border, revealing that the tile has been carefully plucked from an earlier construction, that it is a relic rather than an independent object in itself, that it bears with it a time, a history.

. . . From ten years earlier, *Psycho-Collages. Papier de deuil* [*Psycho-Collages. Mourning Stationery*] *(pl. 4)*, in

sculpture, devoid of innuendos or hidden aspects, whose primary sense is therefore all the more disquieting. In fact, Raynaud's art distinguishes itself from the Minimalist family, which opted for expressing form alone, freed from all symbolic intent and other pathos. With remarkable continuity, his work—despite the evolution of its forms and its increasingly marked leaning toward an expression pared down to the essentials—is infused with a profound expressive charge whose central focus, indisputably, is the relationship to death.

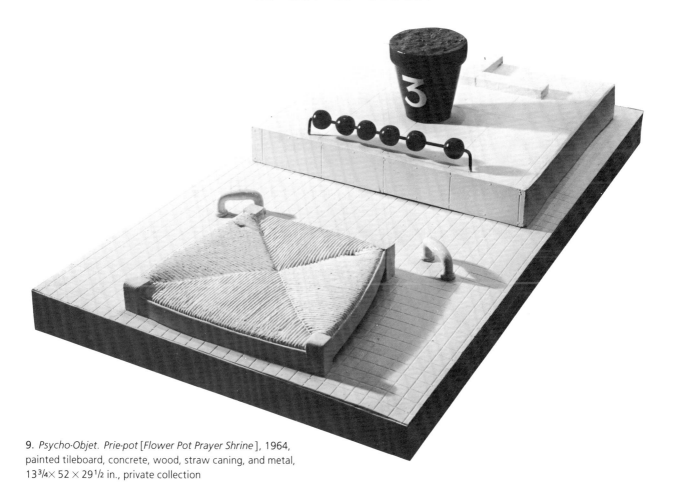

9. *Psycho-Objet. Prie-pot* [*Flower Pot Prayer Shrine*], 1964,
painted tileboard, concrete, wood, straw caning, and metal,
13³/4× 52 × 29¹/2 in., private collection

which a sheet of paper for notification of death, bordered with that thick black line that encloses the suffering the better to emphasize it, is simply glued onto a slightly larger background. The same black border, same enclosure of an empty white space, a possible container of all things to come. Raynaud later uses the term *Espace-zéro,* as though thenceforward everything could start afresh with that *tabula rasa* so reminiscent of the celebrated blank page.

In their duality as in their formal similarities, and although arrived at through rigorously distinct means, these two relatively marginal works address some of the essential issues of Raynaud's art, beginning with the ever-prevalent theme of enclosure. Here reduced to a black line framing a white space, it recurs in a rich variety of forms. It is most obvious at each stage in the construction of the artist's house, but also in the blind sentry box of *Psycho-Objet 27 ans* [*Psycho-Object 27 Years*], 1967 *(pl. 9),* in the coffins in four colors, *Cercueils modèle économique* [*Economy Model Coffins*], 1972 *(pl. 16),* in the *Container zéro* at the Centre Georges Pompidou, in the monumental flower pot in the Fondation Cartier's greenhouse, and also in the photograph so often used in the *Psycho-Objets* that represents a madman half-buried in straw, locked up in a

psychiatric hospital cell. (Most often Raynaud retains only a close-up of the face *(fig. 7)*, but the complete image reveals walls tiled from ceiling to floor, just as he will conceive them a bit later.)

But let us respect the chronology of Raynaud's production. The *Psycho-Collages. Papier de deuil* (part of a series of six collages) belong to the very earliest years of Raynaud's work, when he was building a vocabulary. Although drawn from everyday reality, as was that of many of his contemporaries, Raynaud's vocabulary confronted pain and death from the outset. When he created his first constructions in 1962, Raynaud was only twenty-three years old. Already his style was inexorably established. Slightly older artists to whom he felt close, especially the New Realists like Arman and the Affichistes, provided him an anchoring point. Unlike artists who held onto pictorial composition, including Rauschenberg in the United States, Raynaud challenged the recognized authority of painting. He found his materials at the Gennevilliers city dump near Paris and fashioned them into vaguely disquieting assemblages—minus the grinding humor of a Tinguely or a Spoerri—in which broken bottles and butcher hooks replaced flea-market wares. One of the earliest of those compositions, which combined two one-way street signs, bore the precise title *Sens + Sens (pl. 1)*: its purpose was not to lead the viewer to decode a double meaning, [1] but rather to point up an overload of meanings. Already Raynaud seemed to be saying that through simplification, or derision, art had placed excessive strictures on the merging of form and meaning. This he made his principal objective, thus returning to another New Realist who is perhaps his model, and to whom he later paid homage: Yves Klein.

Raynaud was born in Courbevoie, a working-class suburb of Paris, some months prior to the outbreak of hostilities that led to the Second World War. His childhood was marked by his father's tragic death during a bombing. His studies—unusual, to say the least, for a future artist— led him to horticulture school. Memories of his schooling

are clearly present in his recurrent image of a flower pot *(fig. 9)* and, more generally, in the sensitive response to nature that marks every stage of his work. But his first assemblages were born in secret and isolation, after a period of virtual inactivity. They bear in common a sort of reduction of signs (diametrically opposed to Arman's accumulation, for example) and a depletion of the means deployed: the limitation to one or two colors, red and black; the use of a symbolic element such as the one-way street sign, which was soon to appear more and more; crude, uncompromising compositions devoid of aesthetic effects; and the idea of a wall, conveyed through the appropriation of various construction materials such as fence boards or tileboard, which prefigures the ceramic tile works. Drawing on the intuition of a self-taught artist and also undoubtedly on certain influences present in the art immediately accessible to him, Raynaud composed a singular alphabet which straightaway placed him on a distinct and separate course. He neither glorifies nor neutralizes the object. Rather, he proposes a formation in which each element of the combination, used in work after work, contributes its own specific characteristics: ''sens + sens.'' This proliferation of meanings only becomes more pronounced when a cross or a broken bottle or a baluster appears here and there . . . so many eloquent indications of a clear volition to escape any form of neutrality.

This phase of the *Psycho-Objets* extends over a four-year period, confirming and expanding the tendencies of Raynaud's early works. The prefix *psycho*, chosen as the generic title of the series, certainly lays bare the motivators behind these works: *psycho* in the etymological sense, referring to the sensitive soul or, otherwise stated, how to construct sensitive, meaningful works out of common, everyday objects; *psycho* meaning therapy for mental illnesses and other psychoses, symbolized by that unbearable image of a madman shifting the straw in his cell; and finally, *psycho* perhaps like the gods of antiquity, the psychopomps, who conducted the souls of the dead

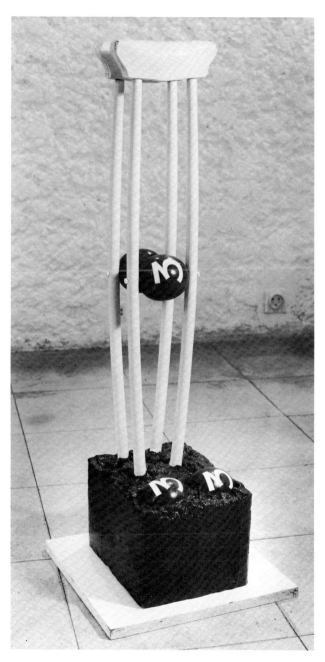

10. *Psycho-Objet 4–3,* 1965, wooden crutches, concrete, and paint, 45¼× 11¾× 11¾ in., Musée national d'art moderne, Centre Georges Pompidou

into the afterlife. Thus Raynaud pursued the *aventure des objets* [adventure with objects], [2] which had been the New Realists' program a few years earlier, but into it he folded an uncommon emotional dimension.

This pursuit is expressed first in the places from which Raynaud draws his sources, described in a series of oft-repeated phrases: ''Sanitary groups: lavatory, bathtub, bidet, mirror, signals, barricades, fire trucks, emergency exits. . . . Every month I visit factories, hospitals, botanical gardens, painting exhibitions, without giving more importance to one than to the other. . . .'' In this clinical universe where hospital and subway corridors merge, where fire extinguishers hang near crutches, one visual common denominator stands out: the color red contrasting with white *(fig. 10).* ''If everything that stops, everything that shrieks, is red,'' writes Raynaud, ''I can't help it.'' It is also probable that plastic considerations and the precedent of Klein's famous I. K. B. [International Klein Blue] influenced him to attempt a new approach to monochromy, one that echoed his own obsessions and anxieties.

Other themes lend themselves easily to analysis, for example, his frequent use of children's toys that are dipped in the color red and emerge saturated with restrained violence. Whereas the toys recall childhood, the flower pot— omnipresent after this series—springs directly from his experience in horticulture school. Propagated infinitely, repeated in various sizes, the flower pot will become *the form* that makes a Raynaud recognizable, which undoubtedly contributed to his rapid success. Soon he removed it from assemblages and used it independently, sometimes as a monumental object *(pl. 12),* at other times as exhibition-happenings mounted from Düsseldorf to Jerusalem in which thousands of copies of the same flower pot became a sort of primary form that reminds us (undoubtedly Raynaud's world invites this interpretation) of the perfectly aligned graves on battlefields.

At this point begins a critical period that will lead Raynaud to space and architecture, during which time

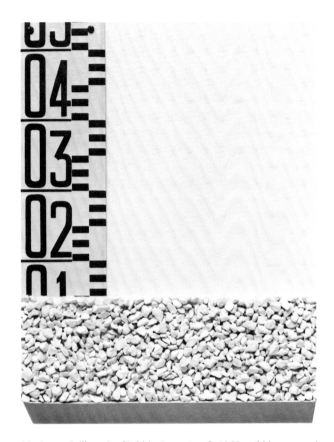

11. *Jauge Cailloux Bas* [*Pebble Gauge Low*], 1969, pebbles, enamel, and vinyl, 21⁵/₁₆ × 17³/₄ × 2 in., private collection

he is creating objects as well as installations, both permanent and temporary. Each *Psycho-Objet* remained an assemblage based on a mental game played with a predetermined alphabet. Each received a sort of chapter heading describing its principal characteristic, which was repeated in the title: . . .*-parc*, . . .*-tour*, . . .*-maison*, etc. Each work from the next period of walls and gauges, however, seems to have been extracted from a complete space—a wall, floor, or ceiling—from which a piece has been appropriated. Even if this appropriation is sometimes grouped with utilitarian objects, such as fire extinguishers or ladders, these works do not possess the single distinguishing characteristic that defines each

Psycho-Objet. Rather, the works of this period are differentiated by their size and shape, and by the way they are situated in a space: the gauge that figures in almost every one of them establishes each work's dimension *(fig. 11)*. Thus, while retaining the key elements of his formation—the color red, clinical objects, cold materials—Raynaud places them within a space and henceforth often blurs the line between the work of art and the inhabited space *(fig. 12)*.

The first commissions from individuals for spaces displaying objects typically used in his work, or for walls integrated into a preexisting piece of architecture, date from this period. At this same time Raynaud begins the work on his *House,* and with it the discovery of ceramic tile as his primary building material. The *House* will become the "magnum opus," ever in transformation, both a living space and a space for experimentation, like a laboratory. Its mood changed over time, moving from the blockhouse stage to the less severe variations of recent years. We will limit our comments both on this subject and on Raynaud's numerous architectural projects since Jean-Luc Daval examines them elsewhere in this catalogue. Clearly, however, Raynaud's involvement in the area of on-site installations is such that it cannot be separated from the development of works created for exhibitions and commissions; nor from the artist's projects on a monumental scale; nor, of highest importance, from the evolution of the artist's house.

If the turning point in the early 1970s is Raynaud's new connection with architecture, perhaps we should also emphasize the role of repetition, which will soon characterize almost all his sequences. In the same vein as the rows of flower pots or the large mural compositions—all based on the repetition of a single form, for example, *Mur sens interdit* [*One-Way Wall*], *(pl. 15)*—Raynaud so perfectly masters the letters of his alphabet and is so confident of their visual impact that he knows he can cover an entire surface this way. Paradoxically, this principle will lead to a break: the repetition of the same object in four

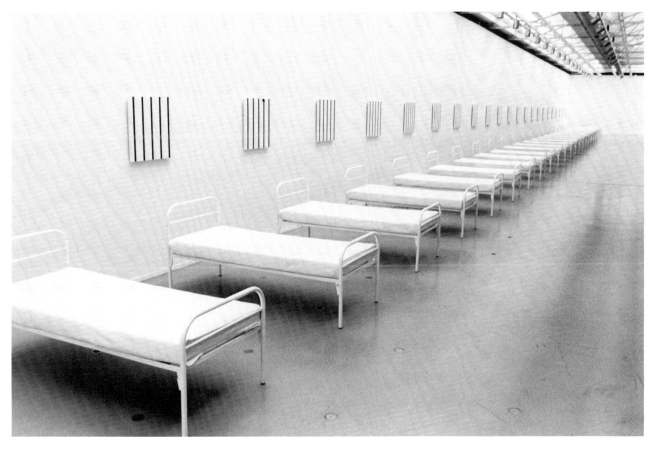

12. *Manifeste,* installation view from "Noir et Blanc," at ARC, Musée d'Art moderne de la Ville de Paris, 1985

primary colors abolishes the principle of monochromy, creating a fissure in an aesthetic turned too predictable for its creator.

The four-color period is the one in which the artist's obsessions are expressed most blatantly. Mortuary ornaments, coffins, and instruments of death possess an aggressiveness in the spaces in which they are situated that contrasts with their astonishing liveliness of color. Following an exhibition that traveled to some of Europe's most prestigious contemporary art museums, thus asserting Raynaud's particular style, he signaled his will to eschew a systematic language. Raynaud likes to take risks in his visual permutations and combinations,

thus expanding his aesthetic choices within an already defined mental universe from which he cannot escape. The four colors were for Raynaud, as he said, "fireworks," a way of exorcising the limited vocabulary of his first assemblages while still pursuing a rigorous approach. At the risk of falling into decorativeness, he had to pass through this rather short-lived phase.

As the interior space of his *House* gradually took shape, virtually all Raynaud's works were derived from another form of seriality, namely, that of tilework, which can assume any form, becoming a stela, a pedestal base, a wall, or a painting, as needed. Given these circumstances, Raynaud's strength came to lie in associating a form, which

13. *Espace zéro,* permanent installation, Hara Museum of Contemporary Art, Tokyo, 1981

self-portrait *(pl. 24),* of a stela liberated from time—neither modern nor classical—of a tile "painting" hung in zero-spaces made of the same material *(figs. 13, 14).* Expressed graphically in a black and white linear network, the same material will be adapted with unprecedented effectiveness in his modern stained-glass windows for the Cistercian abbey at Noirlac. Over the years other experiments emerged: associating the tilework with the tricolor French flag whose colors then exploded with visual immediacy *(pl. 29),* as did the earlier series of objects in four colors, or, conversely, emphasizing horizontality and verticality by juxtaposing two thick black bars and a tiled pedestal base. Oddly, each of these sequences can be understood as the rediscovery of the exceptional, if scarcely predictable potential of a common, widely used material.

The successive phases of its formation thus laid out, it is clear that Raynaud's work does not fit into a linear development, no more than it systematically seeks to update its catalogue of forms. From time to time a different object, or the reuse of an object from an earlier period, signals a new phase. But such choices are far more intuitive than calculated. And they are always grounded in those governing elements that provide the work's skeleton and, beyond its subject matter, hold it together visually.

The flower pot is the transverse component of this framework. At first *the image,* then over the years one image among others, it nonetheless retains its privileged status since Raynaud reintroduces it regularly, never completely giving it up. At first bearing a quasi-auto-biographical meaning, the flower pot gradually shed its anecdotal qualities. From being filled with cement, it passed to being cast in concrete and covered in the colors least related to its first function: gold, pink. . . . It recurs in numerous configurations: stacked in unending columns, it pays homage to Brancusi; monumental and overlaid in gold leaf, it evokes Buddhist ritual statues; in crude concrete, it becomes an archeological fragment of the present. By progressively blurring its original symbolism, Raynaud has

is almost perfectly abstract and, as much as possible, neutralized (always the square, always the black/white contrast), with all kinds of figures and objects in time and space. If the tilework can function equally well as a support for a Neolithic skull *(pl. 27)* or an industrial container *(pl. 26),* if it can literally bring together an Etruscan vase and a similarly shaped flower pot painted black *(pl. 28),* it is because in Raynaud's hands this material takes on a universal quality. Even when employed solely by and for itself, the material assumes the form of a strange

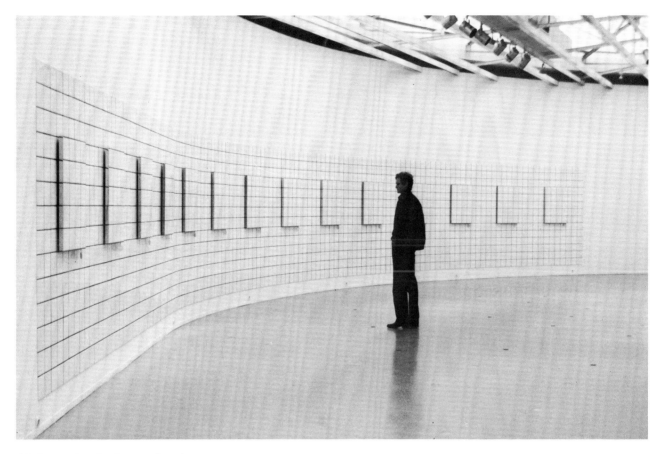

14. *Espace zéro,* view from ''Noir et Blanc,'' exhibition at ARC, Musée d'Art moderne de la Ville de Paris, 1985

dealt with the flower pot as a simple form capable of accommodating changes of scale as well as treatment in series, a veritable leitmotif that sometimes fades away only to reemerge stronger and clearer.

Ceramic tile, on the other hand, is literally the foundation, the base of the work. Even when concealed or obscured, as in certain recent pieces, it remains a building material with innumerable aesthetic qualities. Unlike the flower pot, it was the *image* of tilework, in the form of tileboard that preceded the use of real ceramic tile— proof that within its formal pattern lay an obsessional characteristic that corresponded perfectly with Raynaud's penchant for simplifying and enclosing. For a body of work

that seeks to break loose from the notion of ''object,'' the ceramic square, repeated *ad infinitum,* remains the ideal solution for occupying all available spaces *(figs. 13, 14).* Removed from time, it serves to structure objects and odd places alike, finding their complete realization in inhabited spaces.

— *Translation by Karen C. Chambers Dalton*

Notes:

1. Trans. note: In this context the word *sens* signifies both *direction* and *sense,* i.e., *meaning.*

2. *Aventure des objets* is the title of a book by Camille Bryen dating from 1937 to which Pierre Restany referred several times in the fundamental texts of New Realism.

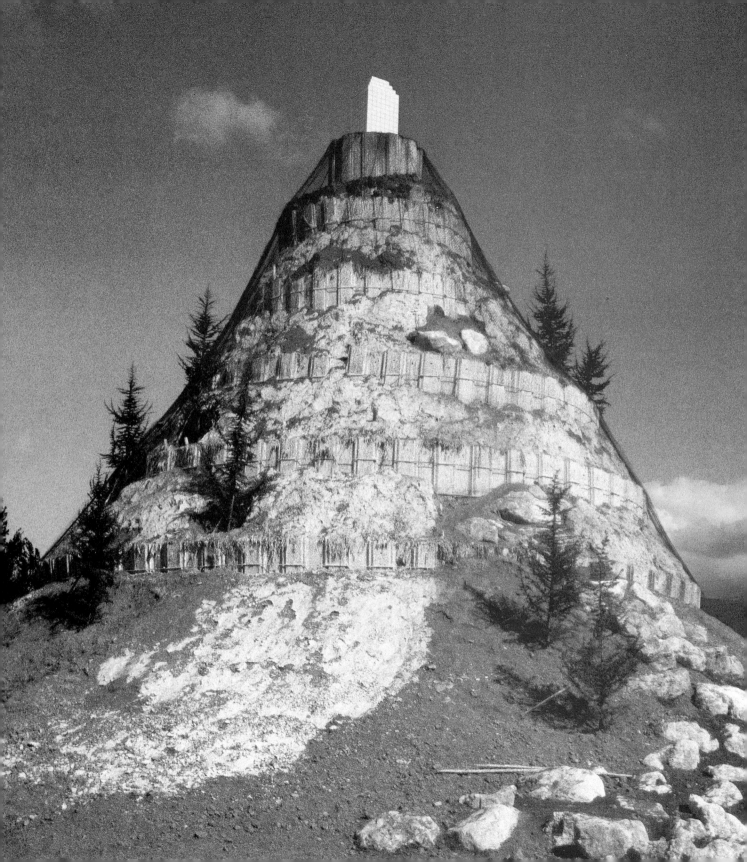

THE MONUMENTAL WORKS

JEAN-LUC DAVAL

If you speak about the notion of monumentality—that is, of works that by their very nature break free from museums, art galleries, and collectors' apartments, to find their niche elsewhere and otherwise—I think it is important to say first of all that "monumentality" is not necessarily a question of scale or dimensions. Rather, it is a question of ambition, as regards this additional liberty of intervention that the artist undertakes. I am thinking, for example, of Malevich and his research concerning architecture, which went no further than the sketching stage, or of Mondrian's experiments in this area. They both had a much broader, vaster vision of space, whether in relation to painting, sculpture, or architecture as such.

Concerning my own work, if you look at it in its totality, I think I can say that this notion of an expanded art has always been inherent in it. [1]

—Jean-Pierre Raynaud, May 1986

Dimensions of the Concept of Expanded Art

The historian of contemporary art can have two functions: authenticating works by attesting to their originality, or presenting them to be seen differently by placing them in a historical context, whose previously obscure areas they clarify with enlightening solutions, just as they themselves unleash new potential directions in art.

We shall assume the latter attitude in addressing this important aspect of Jean-Pierre Raynaud's creation, the one that flows from the notion he calls *expanded art*,

something that the museum cannot contain because it surpasses that cadre not only by its physical dimensions but also by its functions. Interrogation of this impossible appropriation will lead us to reconsider numerous definitions, the hierarchy of the arts, concepts of integration in architecture, indeed, the basic reductionist role that the museum has played, by its very existence, in the interpretation of sculpture.

This attitude is all the more necessary in the complex, fluid context of the 1980s, hastily and promotionally lined up beneath the flag of a regressive postmodernity. Jean-Pierre Raynaud remains an avant-gardist, refusing all mannerist nostalgia; through their determined insistence on a life free of all compromise, his creations constitute an existential adventure that gives an altogether other sense and presence to art. He compels us to enter into his game, into his vision. He achieves this by radically, though minimally, modifying the real in carefully chosen settings whose space he qualifies by giving them new scope.

Even though he expresses himself essentially in right angles and gridwork, in white and black, it would be false to rank him among the current "Neo-Geo" school. If he lays claim to the heritage of Kasimir Malevich and Piet Mondrian, it is not to replay their scores; rather, he shares their intuitions and their stringent requirements. He belongs to their family. Living in a different historical moment enables him to go beyond what was for those pioneers an insurmountable barrier: the hierarchy of the

15. *Tumulus Espace jardin, Saint-Martin d'Hères*, 1978

arts and the division of its practices. Thus he will be able to bring new forms and functions to art.

From the Second to the Third Dimension

In the epigraph, [2] Raynaud underscores his filiation with Malevich and Mondrian by citing their space creations. Yet, until the last few years, [3] these were little known and even less understood. There were a few scattered photos of these three-dimensional works, and several commentators had noted their significance with respect to architecture, the ultimate solution to a painting termed "objectless" or "nonobjective," but our concept of architecture remained as it had been defined by Walter Gropius: "Architecture is the goal of all creative activity. To complete it with decoration was once the principal task of the plastic arts. They were all part of architecture, and they were indissociably linked to it," [4] an idea still weighted down with the functionalism that the Bauhaus, in the course of its development, ascribed as the purpose of the plastic arts.

Who, in fact, until now has studied Malevich's *architectones (fig. 16)*—to which he devoted ten years of work, creating the *studios* and "Madame B.'s salon"—and Mondrian's decor for "The Ephemeral Is Eternal" *(fig. 17)* as works of Manifesto Art, like the Readymades (including the famous *Fountain*) of Marcel Duchamp, which for over twenty years have been defined, on the theoretical level, as being the initiatory acts of contemporary production? Jean-Pierre Raynaud's on-site constructions lead us to reconsider Malevich's and Mondrian's creations, just as they demonstrate that it was somewhat simplistic to divide the historical evolution of art into *before* and *after* Duchamp, because there are other sources. Through his concept of an *expanded art,* Raynaud proves that he has abrogated painting's and sculpture's subordination to architecture in favor of another definition of art as a *complete experience* or *total work* wherein the

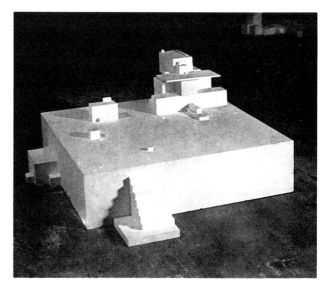

16. Kasimir Malevich, *Architectone,* 1929

boundaries among these techniques disappear. Besides, such distinctions did not even exist until the eighteenth century, and the entire history of contemporary art since the invention of the assemblage has called for their suppression. [5] It was impossible to understand what Raynaud's spiritual fathers were saying as long as these divisions, of relatively recent usage, were being respected.

Malevich recognized that "modern art is neither pictorial nor imitative; it is above all architectural." In 1920 he wrote: "Suprematism in its historical evolution has had three stages: black, color, and white. All these periods elapsed under the conventional signs of planar surfaces expressing, so to speak, the floor plans of future volumes, and indeed at the present time Suprematism is growing in the time-volume of new architectural construction." [6] Still, his idea of architecture was quite different from the functionalist type being developed by the Constructivists, which was indeed one of the causes of his break with Tatlin.

Malevich implicitly dismissed the mentality of architects when he wrote: "The architectural edifice is nei-

ther a factory nor a manufacturing plant. It is a system of the world of art for other non-objective affectations, into which is led the whole nervous system exacerbated by the effort to reach beyond into quietude, toward the non-objective." [7] This allowed him to be highly critical of the Productivists: "To my keen regret, most young artists here proclaim that the spirit of artistic renewal is to be found in the new order of political ideas and improvements in social relations. Consequently, they have all become, in a sense, followers of governments. . . . They forget that no idea can reach the value of the Art idea . . . and that it is in Art and not in any other circle of ideas that the world and Life can find elements of beauty." [8]

Mondrian thought no differently: "The plastic expression of equilibrium can prepare the way for humanity's plenitude and mark the end of art. Art has already begun its own destruction, but now the end will come too soon. Art's regeneration through life is not yet possible; another kind of art is still needed in our time. You cannot build a new art with old materials." [9]

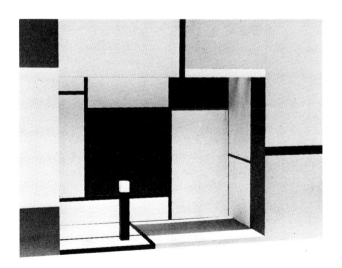

17. Piet Mondrian, model for "The Ephemeral Is Eternal," 1920

With his *architectones,* Malevich was preoccupied with external forms, whereas Mondrian worked exclusively on interior surroundings, the space of the in-within. (We shall see that Jean-Pierre Raynaud is just as preoccupied with the one as the other, and that the inside-outside relationship is even basic.) But for the Dutchman, too, painting one day would be surpassed by "constructions for life."

In "Home, Street, City," the basic text written in 1926 around the time of his break with Theo Van Doesburg, whom he had known during his three-dimensional projects, Mondrian wrote, based on his spatial experiments in his studio at 26 rue du Départ in Paris: "In order for our material environment to have a beauty that is pure, and therefore healthful and practical, it must no longer be a reflection of our own petty, self-centered feelings. It must no longer even be a lyrical expression of any kind, but rather be purely plastic. . . . Through an elaborate but varying rhythm of plastic relationships verging on the purely mathematical, this art can nearly reach the superhuman and certainly the universal. And this is possible, already in our own time, because Art precedes Life." But later, Mondrian clearly showed the functionalist limits that restrict Neo-Plastic construction: "Personally I do not see, at present, how it would be possible to arrive at a perfect plastic expression solely by following the organism of what one wishes to build and by being preoccupied only with its utility. To this end, our intuition, already overloaded with the past, seems underdeveloped." [10]

In an article published in 1922 entitled "Der Raum. Ein Beitrag zur Wissenschaftslehre in Kunststudienen [Space. A Contribution to the Science of Learning]," [11] Rudolf Carnap distinguished among space's various appearances in a way that perfectly illustrates the problems laid down by artists of his time. He defined three spaces: R1, formal space; R2, intuitive space; and R3, physical space. The problem of artists of that time would have been to pass from an abstract thought, linked to the plane, to physical space, linked to sculpture or architecture. But

this passage from painting to space was all the more difficult, for each application seemed to derive from disciplines that the habits of the period prevented from being decompartmentalized. This was what Mondrian was still saying as late as 1931: "Plastic expression belongs to a period and is its product. . . . To date, all plastic art could be developed, continued toward pure plasticity. But once this is denied, one can go no further in art (*or in painting, may I specify*). But will art then still be necessary? Is it not merely a poor artifice, as long as beauty in life itself is wanting? Beauty truly realized in life . . . that should be more or less possible in the future." [12]

Raynaud will be able to give a positive answer to this intuition, because he will live in an age which will have lifted the barriers created by the compartmentalization of art practices.

The Viewer's Role and Sculpture's Evolving Definition

A great many contemporary art works are made using elements so extreme (the square, the grid, monochromy) that they wind up resembling each other so closely that only their author's signature differentiates them. The viewer, then, cannot remain passive and must be *forewarned* if he wishes to make sense of the object submitted for consideration. Since the beginning of the twentieth century, the viewer has been led to assume an increasingly active role, not only at the conceptual level— according to Marcel Duchamp's dictum, "It is viewers who create painting"—but also at the perceptual level, as is proven by the development of sculpture.

Between 1920 and today, the relationship between sculpture and viewer has changed considerably due to the evolution of society and of art. A Raynaud work cannot be interpreted outside this consciousness. His concept of *expanded art* stands within a development of work with and inside the space that it sublimates. It arises from a

form of sculpture (I retain this term, for since the invention of assemblage in 1912 nearly everything that is produced plays upon the reality of the third dimension) into which will be reabsorbed the problems of painting and which will rejoin the most highly purified nonfunctional architecture, namely, pyramids, obelisks, or cupolas. . . .

Let us not forget that it was not until the end of the seventeenth century that the artist, who until then was a creator who could express himself in any and all domains, began to become a specialist. [13] This division accelerated over the nineteenth century and reached its high point at the beginning of the twentieth century. Meanwhile, architecture had debased itself in passing from utilitarianism to functionalism.

If painting had been only slightly affected by this division of practices, sculpture was by its decree limited to statuary and reduced to the function of art object, to such an extent that it was not until 1964 that Herbert Read made a first restriction (with regard to Naum Gabo, who was the promoter of another notion of sculpture): "We will continue to call 'sculpture' all works of art in three dimensions, but the modern era has greeted the appearance of three-dimensional works that are neither sculpted nor molded. They are erected, as in architecture, or assembled like a machine." [14] And when Rosalind Krauss evoked sculpture of the 1970s, and earth works in particular, she felt even more deeply the separation between today's art and traditional definitions: "So sculpture can reach vast proportions, not to include a site, but rather in such a way as to take into account the challenge that it poses to the concept of form. It may also happen that the limits of a means of plastic expression give way at the same time as the non-site ushers in a practice that can no longer adequately be defined by the term *sculpture*. . . . Historically speaking, it follows from this situation that, at the end of the 1960s when sculpture reached monumental scale, the conditions of this approach brought on precisely the dissolution of the 'sculptural' as such." [15]

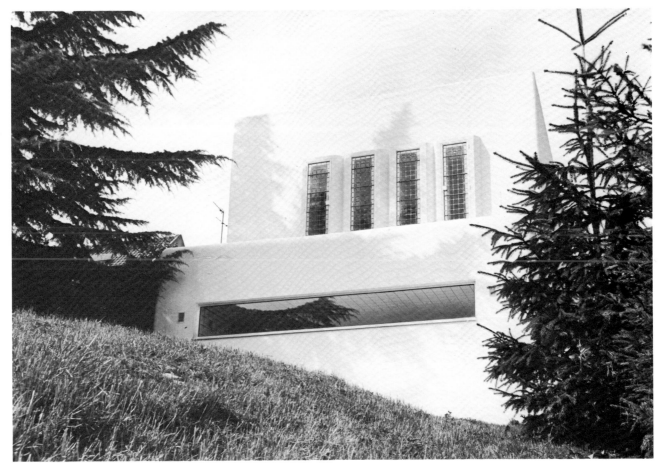

18. *House,* exterior view, c. 1977

With the concept of *expanded art,* it is not the sculptural that is condemned, but the inadequate definitions it has been given. Nor should we neglect the role that the museum, by its mere existence, has played in perpetuating these faulty definitions, by taking sculpture away from the functions that it formerly held in the city. This began occurring in the nineteenth century, when public art commissions were less oriented by artistic considerations than by political necessity. From that time on, the art of sculpture could only continue losing societal space. It was not to be recovered until after 1950.

In defense of museums, one could nevertheless imagine that it was because of having lost all functions except the aesthetic that ideas about the third dimension could be put into practice and enjoy, at the beginning of this century, such a rapid evolution and such meteoric metamorphoses, its creators encountering no obstacle to their desire to go increasingly further.

With the invention of assemblage, Pablo Picasso introduced another way of sculpting, i.e., construction, and gave it a new dimension, space, which under the name of *void* was to become an essential constituent dimension. This new type of sculpture progressively freed itself from the pedestal, renounced statuary's traditional

verticality, and was worked out using heterogeneous contemporary materials. At each stage of this evolution, the viewer's relationship with these constructions became narrower and more complex, calling for perceptions on a great variety of levels. Gradually, the dimensions grew larger; sculpture, an *object to be seen,* was transformed into a *space to be lived.* By 1968 this had been accomplished with "environments" and "land art," through modifications of reality itself within reality, which renewed our understanding of nature and its rhythms by reaffirming the viewer's involvement.

Raynaud's Place in the Evolution of the Sculptural

At first Jean-Pierre Raynaud refused to consider himself an artist since he had not been explicitly trained as a painter, sculptor, or architect. Thus he became involved with the evolution of the sculptural by an indirect route. He only had a diploma from the Versailles Horticultural School (1959), and his rapport with nature remained somewhat ambiguous: "I poeticized with nature before poeticizing with art, but nature did not meet my expectations." [16] Nature was not to resurface in his production until after 1975. In order to identify the signs that would constitute his later visual language, we will dwell briefly on the period that preceded this date. "His production," Gladys Fabre judiciously notes, "was from the outset a vital necessity, a personal catharsis more than the fruit of a desire for aesthetic creation properly speaking." [17] But vis-à-vis his awareness of real space, the work with the *Flower Pot,* and especially his experiments with the *House (fig. 18)* as an environment varying with his inner development, will be determinants of his practice of *expanded art.*

From his earliest works in 1962, Jean-Pierre Raynaud neither painted nor sculpted. He *assembled* signs or found objects from urban reality. In the context of New Realism, he practiced an archaeology of the present; he collected ruins of contemporaneity. Such an attitude would find

another finality when he exhibited his *Fragments* in 1979 (the first ones dating from 1974) or the *Stelae* (1984–85).

He structured his *Psycho-Objets* in series, through repetition and grids, and set himself apart by the economy and rawness of his materials (the appropriated real always has something to do with urgency or interdiction). A result of self-analysis, these depended directly upon his personal internal needs, but they acted upon him in a therapeutic way by the distance (cooling or enclosing) at which he held them. The plunge is narcissistic, but the subject takes no pleasure in the mirror.

This holding at a distance evolved at the same time as the artist selected the terms of his vocabulary. In the end he kept only two of them: the flower pot and the tile square.

The first flower pot, filled with cement, appeared in 1962. It was the object of a work concerning loss, grief, death. Raynaud made it nonfunctional, with numerous interdictions projected onto it in settings developed from the appropriation of his mental universe. But progressively the flower pot also asserted itself as the support for a spatial experiment on the relationship between fullness and emptiness, one of the basic problems of modern sculpture. In 1968 he made it as tall as himself (5 ft. 11 in.); in 1971 he used it to structure an urban plaza, multiplying it by 4,000 in London and in Jerusalem *(fig. 19)*; in 1982 he stacked them up to erect an endless column; finally, in 1984 he made it 11 feet 6 inches tall, covered it in gold leaf, and enclosed it in a greenhouse at the Fondation Cartier. Only this latter work fits the concept of an *expanded art.* But already the flower pot, as the ceramic square was later to do, urged itself upon Raynaud as an element in a strategy allowing the physical escape from time: "By simplifying the relationship to the object and by making only this flower pot, I avoid the question of the evolution of time. If today I remake the same flower pot I made in 1962, I slightly abolish the notions of time and history." [18] For him, the expression lay beyond the material, in the space that it engendered.

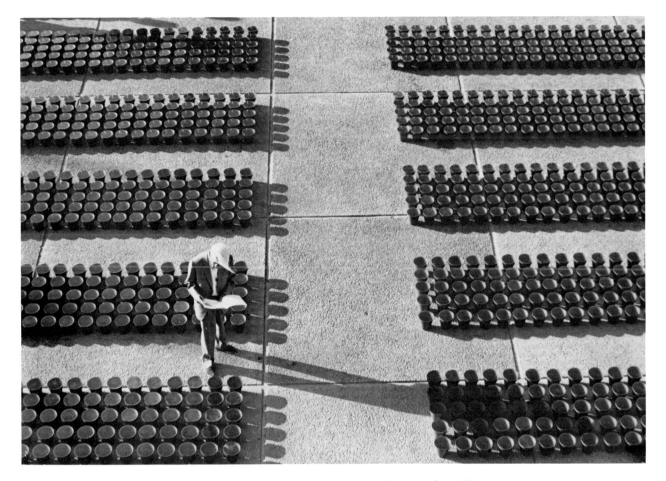

19. "4,000 Flower Pots by Raynaud at the Israel Museum," outdoor installation view, Jerusalem, 1971

When he juxtaposes or superimposes his flower pots, Raynaud seems to produce installations that, in terms of form, may relate to those by American Minimalist artists, but such interventions take on another sense once one knows that they represent the image of a nomadic and public *self*, as opposed to the sedentary image of the *House*, a fixed receptacle of the self in evolution, and of which he is the sole interlocutor.

The white surface set in black appeared for the first time in 1964 in the *Psycho-Collage* series in the form of mourning stationery. Roughly rectangular, it became square through the use, in the same year, of tileboard. Although the first ceramic tile appeared in 1965, it was not to come into its own as a basic element of his visual vocabulary until 1968–69. It became for Raynaud the counterpart of Malevich's "black square," i.e., the void where he could "live life through an idea of death," the Great Beyond of all representation, and, to repeat the Russian Suprematist's expression, a desert "extending to where nothing else was authentic except sensibility alone, and this is how sensibility became the very substance of my life." [19]

31

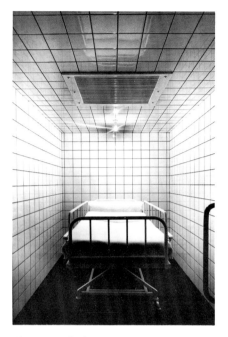

21. *House,* bedroom, August 1974

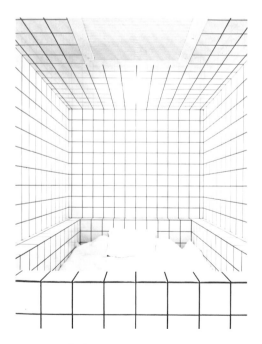

20. *House,* bedroom, January 1974

A Private Demand: The House

It is in the adventure of the *House* that the square ceramic tile becomes the key element of his language. The *House* is an essential part of Jean-Pierre Raynaud's development. It is the place where he developed his concept of *expanded art,* a womb whence, having gone to the limit of himself, he could come forth to encounter other people. Since a major study has just been devoted to the *House,* [20] we will limit ourselves to touching briefly on its stages, whose echos are to be found in his *expanded art* projects.

In 1968, in La Celle-Saint-Cloud, Raynaud bought a long, narrow lot, which was to dictate the overall shape of the *House.* It was only supposed to be the home for Raynaud and his wife: "I was living through a very difficult time in my private life. The house was not an emulation. In some ways, I did it as though it were my burial. A year and a half later, I got divorced and found myself alone again. In an instant, I reclaimed my territory, I marked my space, a little like a cat does, and said to myself, 'I must do something with it.'" [21]

This was in 1970. Raynaud first transformed the house into a "psycho-object" that suited his needs, varying it in response to the evolution of his private demands. Both a place of reclusion in which to go to the limit of himself and an asylum to protect him from others, nothing there represented any obstacle to the physical and spiritual encounter of his ego. A theater for the psychodrama of a voluntary prisoner, it also appeared as an illustration of the myth of the Cave. Living with the idea of death should allow it to be transcended. Certain "psycho-objects" already had been shaped like a house, but they were restricted to the exhibition space, as finished works to be viewed and interpreted. In his *House* the experiment had to be total, since it unfolded in a place lived in day after day, year after year. This change of scale was fundamental.

Starting in September 1970, Raynaud began using ceramic tile for the music room: furniture, walls, and ceiling. "From the moment the tile began to invade everything,

I could observe that I was caught in a mechanism with no exit. Either I plunged into it completely, or else I got ready for another adventure altogether. At that moment, I became the center of a psychodrama." [22]

On the plastic level, the tiles represented an immersion into monochromy beyond mere painting, an entrance into a serial, modular space, one that generated environments. Raynaud had encountered this material while making the dining-room table for J.-M. Rossi in 1968, out of 15 x 15 cm tiles with anti-acid joints 5 mm wide: "My stroke of luck was to have had the intuition of the size for the tile and the proportion of the joints." This mechanical whiteness afforded him the distance and the cooling effect that he needed, but in the *House* it imposed a gridwork on the space: "There was a white, and there was a structure:

the white brought its own absolute dimension, but on the other hand, the lines gave a structure to this absolute. It had to be, at the second degree, a revelation for me: the imposition of a grid on the space, linked to the whiteness, gave me a feeling of security and equilibrium. The white struck me as possessing all qualities: it was sustained, and yet it was free. Compared to a Klein monochrome, it had structure besides, therefore it was an architecture." [23]

The mechanical tile square is clean, empty, neutral. It is used for laboratories, bathrooms, and hospitals. Materially speaking, it has no connotation whatsoever; but psychologically speaking, it has many. It allowed Raynaud to build a place where he could disappear in order to be reborn. As the tile surfaces gradually took over, the *House* was emptied of comfort and information, to

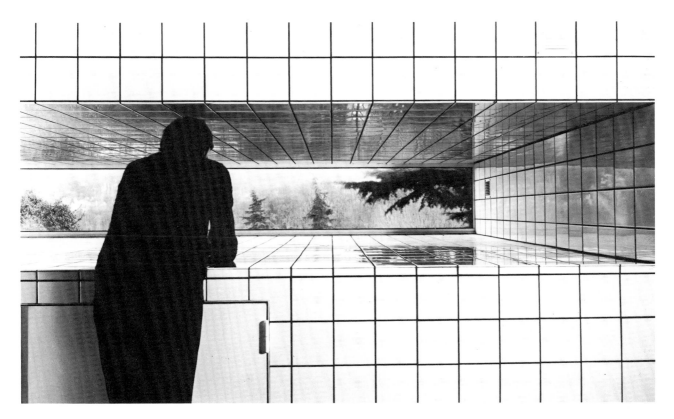

22. Raynaud looking through the gun-slit window of the *House*

be transformed into a mental space, a space where his imagination could function freely.

From 1971 on, the feeling of cloistering accelerated *(figs. 20, 21)*. The *House* became a womb, a zero point: all life was inside it, beneath it. It progressively took on the appearance of a bunker: all its openings closed up, its access became fortified *(fig. 22)*. Until 1974, this descent into self grew increasingly radical, and visitors considered it a deathly place. Raynaud was deep inside something that more and more closely resembled himself; he occupied a territory where the best or the worst could intervene. He devoted all his time to it, pressed by a need to follow his instinct to the limit. Progressively, the square that structured and ordered the space gave rise to an equilibrium: "I suspect the tile surface revealed it to me; I felt that it had dynamic capabilities. The space bore me on, drawing me into even more tilework." [24]

Opening to the Public

Everything was to change in 1974. "1974 corresponded to the summing up of an experiment. The house grew more and more closed, and for the first time it had an architectural autonomy. I had reached the moment when a decision had to be made: either I continued indefinitely in this cloistering and got all the masochistic mechanism from it; or I artistically idealized this state and shut myself out of it, because one does not live inside a work of art; or else I lived this fundamental artistic experiment. I was aware of the irreversible aspect of the matter, of the strength and isolation it supposed." [25] Artistically, his goal was now defined: to create the maximum visual tension with the minimum of elements. From then on, he mastered his medium and his space.

In the crypt that he had just finished tiling, which he had transformed into an exhibition space, he installed his first tile "painting," zero-surfaces articulated on the same principles as were the walls of the *House* and of which they

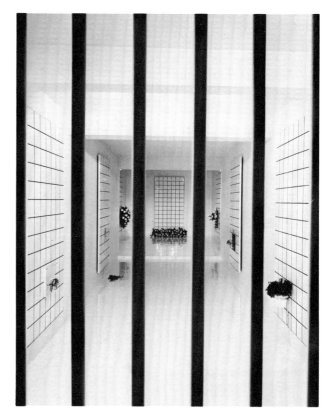

23. *House,* crypt, 1974

were but pieces. On March 5, 1974, he officially opened the *House* to the public, since that was where his works had originated and it was the house that justified them. "The notion of a studio never existed in my case.... Each object that I made took its place in space according to an order that seemed self-evident to me.... At that moment, the space's totality conditioned the works. They all had the same dimensions, and while being independent, they were part of a whole, since they were secreted by the place that had given birth to them." [26]

Now ready to let others in to see him, Jean-Pierre Raynaud communicated to them the experiences of someone who had gone to the outer limit of himself, beyond the void, up to the very edge of death. He spoke

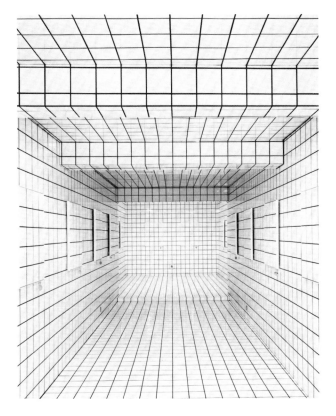

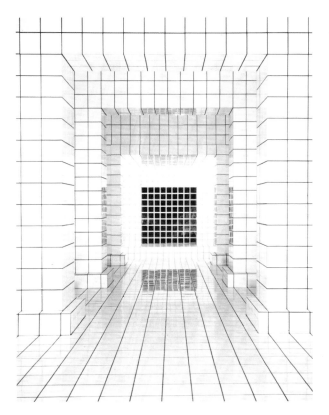

24. *House,* crypt, 1975

25. *House,* crypt, 1987

only of himself, but he had imprinted a way of living upon the material and upon his space.

From that time on, the *House* was to remain the laboratory where he experimented with the ever-increasing number of shock waves that the outside world provoked in him. It was a place in constant metamorphosis *(figs. 23–25),* where what nature and culture suggested to him would be appropriated. Sure of himself, as well as of his vocabulary and his space, he could look beyond his ego, but what he then encountered was to be measured against the scale of his absolute.

The passage from two dimensions to three dimensions followed the dynamics of the tiling, soon leading him to cover the floor, like the *House*'s walls and ceilings, in ceramic tiles. Henceforth there were no more sides, no up or down. It was in the relationships of volume, its scale and dimensions in the ambiance, that the void is filled with meaning. The transformations of his space generated the desire to preserve traces of its progress: "fragments" or "archaeological stones," mementos of a perfect order destroyed in favor of a new equilibrium: "Each time I had to renounce a certain perfection in order to take another route, to set off once more for the unknown and for what was, fundamentally, the true challenge. This was to reach the point of finally having enough strength and imagination not to regret a form of perfection that had been destroyed" *(figs. 26, 27).* [27]

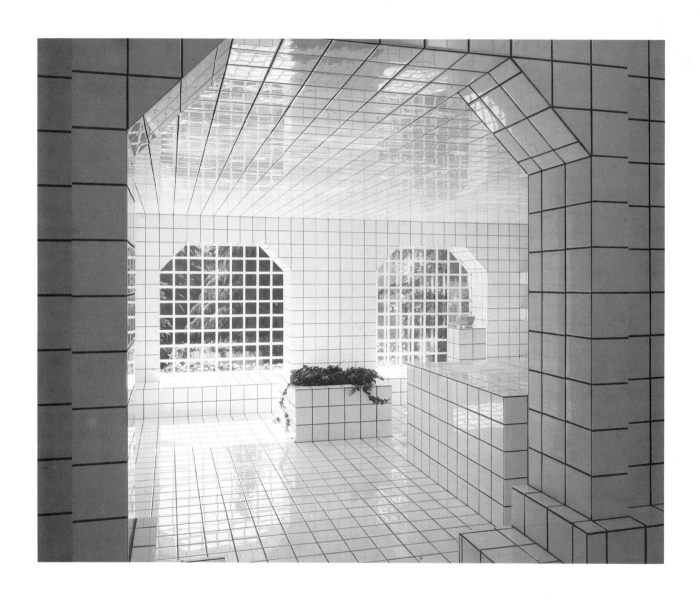

26. *House,* office, 1983

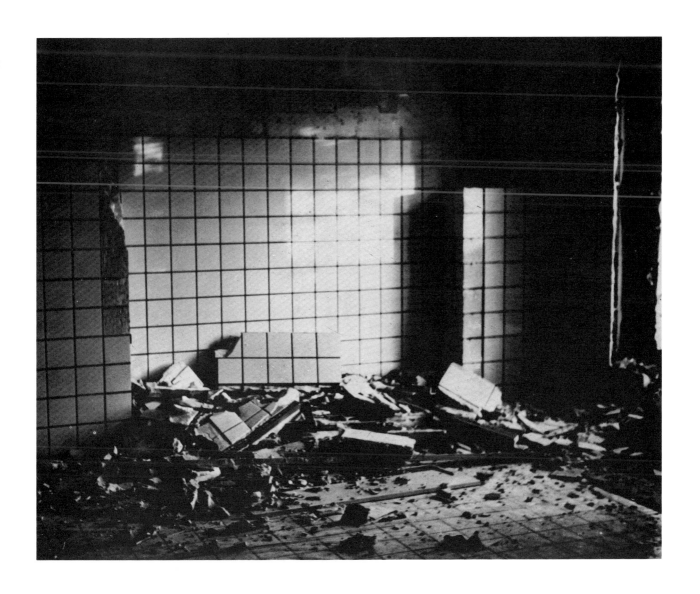

27. *House,* demolition of the music room, 1979

A Return to Nature and to Culture

The zero space he reached in the *House* and those it gave rise to in the world outside, as well as the resulting appropriations, represented the limits of introspection. To repeat them beyond the necessity that had engendered them would be to transform art into an aesthetic exercise, merely decorative. On several occasions, through the radicality of his solutions, Jean-Pierre Raynaud was to bring us back around to similar zero-spaces, works so complete that they could not be surpassed without shifting the set of problems. In fact, this was not a question of last wills and testaments but of existential adventures: "This is my highest pleasure. Trying to pose the problem over and over again. The human being is born in suffering; it has an environment and a body, but not a consciousness. The zero-point is the moment when the individual comes to consciousness, where he can define his plans, choose his way. For me, the zero moment is when a being decides to begin to live: *tabula rasa,* when he has evacuated all his problems with other people and has recovered his adult virginity. This entails posing a more all-encompassing question that will let him unify, accomplish from within himself a synthesis between what is new and what one once was, between one's beginnings and one's end. It is seizing upon a single image from which everything becomes possible, one instant in an ideal quest when an adult holds all the trump cards he needs to design his life." [28]

The event that brought him out of the zero space of his *Bunker House* was the commission for the stained-glass windows at Noirlac in the summer of 1975. Noirlac is a Cistercian abbey in the Cher region of France, with fifty-five tall vertical windows and seven rose windows *(figs. 28, 29)*. This was a stroke of luck for him: "There are projects that sweep everything else aside, that resolve everything. Noirlac was not of the same nature as the *House,* as my ethic of tilework. There were no interferences. I was the one who made the associations.

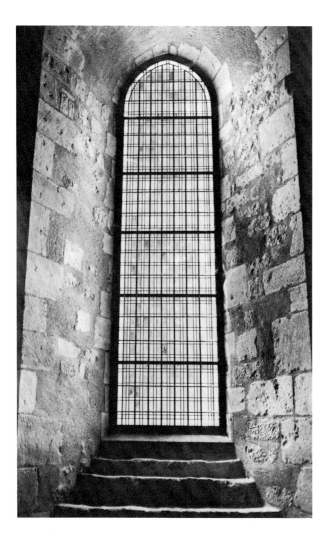

28. Refectory window, Noirlac Abbey, 1976

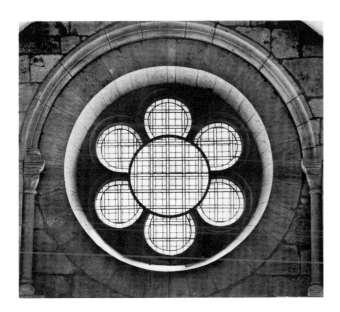

29. Rose window, Noirlac Abbey, 1976

materialization in glass, he experienced the revelation of light and its shifting inflections; he discovered a limitless depth that accelerated passage from the order of objects to the order of mental structures. The stained-glass window reconciled the internal and the external. The success was total, and the experiment decisive for him. He then had to incorporate it in his *House*.

In September 1977, Raynaud built pillars in the crypt to harmonize or humanize the right angles, and he built a table, his first true stela: "That tiled table, I never called it an altar; for me it was always a sacrificial table. Everything that I was able to build in the house, for either philosophical or practical reasons, did not need to serve a purpose; that is what I call architecture. It seemed to me that this place had to have an element of waiting for something, a call to the body, to ritual perhaps. What interested me was not putting anything on it." [31]

Mondrian had not defined architecture otherwise, and it must not be forgotten that he, too, had worked with light in his studios, making it intervene with the mirror's geometric surface.

Now Raynaud brought the controlled, filtered light of Noirlac into the *House*. He replaced the embrasure-like gun-slit window [*meurtrière*] with bay windows, opening onto the world: "It is light that brings about architecture. I hollowed out a calculated placement for light to penetrate and take its place in the house like a piece of furniture. I used light like a color, a golden yellow. Everything changes as a function of time, of the time of day." [32]

The stained-glass window also made him "re-see" nature, from a distance. Having thus rediscovered reality, he put flowers in test tubes and planned the construction of a greenhouse. Nothing being allowed to crop up unless he created it, he would not turn to nature; rather, he would bring it into the house: "The greenhouse, in principle, will be a place where I will not go: for me it will be a *tableau vivant*. . . . It is a relay for dreams. Some places do not need to be inhabited; they only need to be seen with the eyes." [33] This was what he would also do with the stela.

From its beginnings, the *House* bore no consequences beyond itself. My state of mind, and living as I lived, all prepared me for the Noirlac adventure. Nature creates events, and events are linked together." [29]

According to Georges Duby: "It was precisely upon the idea of opening, on the point of juncture between the recluse and the limitless, that his work at Noirlac concentrated." [30] Working with stained glass was like stepping through the screen of a painting's medium, discovering light, space, and beyond them, nature. From the outset, in a series of sketches, Raynaud transposed the tile grids to subordinate them to architectural forms *(fig. 29)* where the circle and the arc played an important role. At the same time, he studied supporting structures and experimented with a new material, glass, with its various thicknesses and transparencies. Seeking new equilibriums, he multiplied its variations; his plastic language was enriched by doublings, by offsets, by superimpositions. Through its

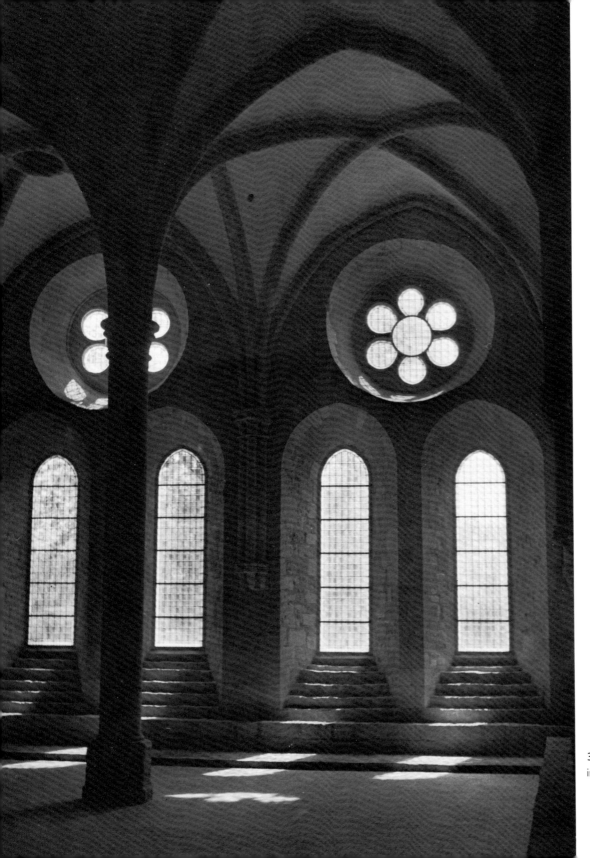

30. Noirlac Abbey,
interior view, 1976

Further, the greenhouse encouraged his discovery of water: its mirrorlike qualities, its music, its movement. His renewed interest in nature coincided with his second public commission, *Saint-Martin d'Hères* near Grenoble: a 600-square-yard garden, an artificial tumulus capped by a stela projecting into the sky *(fig. 15)*. An inverse greenhouse, the architecture's contents is nature itself!

Geography and Archaeology

This opening onto nature transformed Jean-Pierre Raynaud's very life. Before this, he had gone only to places where his art work led him. Now he began to travel freely: five times to Turkey between 1977 and 1979, Afghanistan, Southern Spain (1979), Japan (1981). . . .

The use of ceramic in Moslem civilization enlarged his reflections upon this material: "Tilework presupposes a violence. . . . The fact that from then on I called it *ceramic* shows that I accepted the tenderness within myself. This is an irreversible choice." [34]

The *House* is a perpetual construction site. He had to record therein the sensations to which the world gave rise, so that he could appropriate them to himself. He regulated the house's apertures like diaphragms, controlling the thickness of its walls, shifting them about, reorienting them, while systematically preserving fragments of these metamorphoses. In this archaeology of Raynaud's place, each fragment has a history and retains the memory of an order born of a spiritual adventure. From this time on, he took upon himself as a work ever in progress the "breaking of the tile wall in the dynamic of destruction." Self-destruction encourages rebirth; Raynaud's resurrection is linked to the practice of art.

From his travels he also brought back precious objects: ceramic tiles, fabrics, carpets. . . . He installed them in his house before perceiving that they would distract him from his quest for the absolute. He had to find some way, however, to retain the traces of the transformation

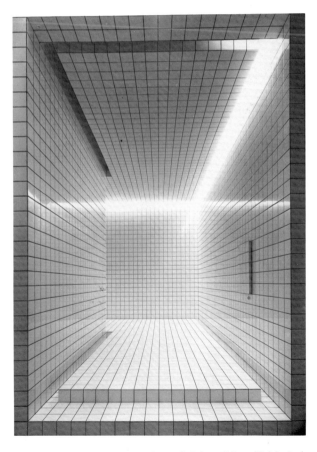

31. *Espace zéro*, entrance, "La Rime et la Raison," Grand Palais, Paris, 1984

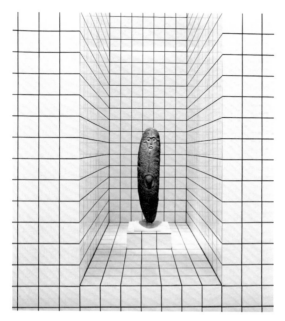

32. *Espace zéro,* niche with 17th-century Nigerian stone carving, The Menil Collection, ''La Rime et la Raison,'' Grand Palais, Paris, 1984

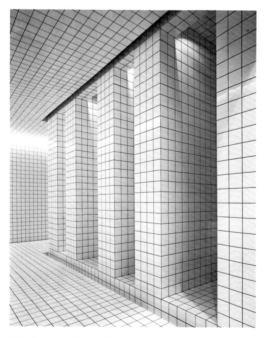

33. *Espace zéro,* niches at entrance, Grand Palais ''La Rime et la Raison,'' Paris, 1984

that they effected, to record the absence of the Kilim by new ceramic floors: ''Their very borders produced an offset, as if the floor had moved and a slight rumpling had been imprinted there.'' [35] Only six Romanesque stone objects were allowed to remain: capitals, baptismal fonts, sarcophagi. . . : ''The Romanesque objects eliminated death and called forth a form of stability, a support, and a link with the outside world. . . . The end itself is emptiness, antiornament, not a sclerotic emptiness that would be an absence, but the proper bare minimum. Finally, by forbidding this, I protect the house. This is my eternal conflict: is one enriched by learning more, or by concentrating on a single *idée fixe*? In its emptiness, in its absence, the house is very strong. It is in the choice of modernity that the problem is posed. In my approach, the modern concept is to go toward the void.'' [36]

This period coincided with the *expanded art* projects in Flaine and Monaco. This experimentation with nature and history was something that Jean-Pierre Raynaud also showed in his exhibitions with stelae bearing elements from nature or culture, where the relationship between the living and the inert became increasingly close.

Progressively, the *House* gained in maturity and harmony: its space became more fluid. Beginning in 1984, due to receiving installation commissions from museums, Raynaud had less need to show it. The 1984 commission for the Grand Palais entrance to ''La Rime et la Raison [Rhyme and Reason]'' *(figs. 31–33),* the Paris exhibition of the de Menil family collections, was particularly determining; he built a space that created a bridge between the past and the present day.

The discovery in 1985 of Etruscan tombs also impressed him greatly, affording him an opportunity to relive another relationship with death, which was to find an echo in the organization of his space. But the problem was no longer there. In autumn of 1988, Jean-Pierre Raynaud definitively closed his house for twenty years to anyone but himself. His space of communication and creation lay elsewhere, in his projection toward other people.

Raynaud and Public Commissions

The Noirlac Abbey stained-glass window commission and its success acted as a revelation: "Taking into account the place, the weight of its history, the strength of its past, its religious function, changing scale with regard to my own experimentation with openings in the *House,* envisioning an edifice in its totality and not merely in terms of my own work within it, and adding to all that my urge to bring something to it of an emotive intensity, of pure sensibility, it would be an understatement to say how much this experience was, and remains, one of the most intense moments of my artistic career." [37] Parallel to this, the experience with his *House* made clear the necessity of being master of his space: "because it is a reflection of oneself. I realize to what extent this is almost a problem of language: what is a 'neutral' space? I think I understand that it is an available space; something can be done with it, as with a big white blank—not empty, but a white blank you can walk around in." [38]

Spaces available to artists are on the increase. For various reasons, from the pursuit of prestige to sociological or urban design failures, public powers have asked artists to intercede, to resolve problems, as if the creator could be assimilated into the police rescue squad! If urgency cannot receive an artistic response, such a demand gives *expanded art sculpture* a function. Because it is needed, it can express the image and spirit of our times beyond all other representation.

But how could so personal an artist find his place in public space, and what could he achieve there? Since Raynaud had never produced any studio art, the experimentation with the *House* made him increasingly apt to welcome monumental undertakings as an inherent part of his approach. On-site work attracted him all the more because it involved taking risks. Linked to duration, the response must be perfectly appropriate, and each site, like every commission, required it to be different: "For me, the museum experience is very interesting.

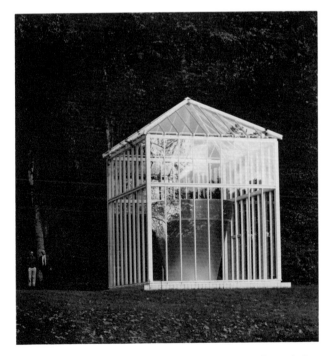

34. *Pot or monumental* [*Monumental Gold Flower Pot*], Fondation Cartier, Paris, 1985

35. *Le Soleil noir* [*Black Sun*], maquette, Flaine, 1981

It reminds me of worshippers in their chapel; each one has his territory and gets something out of it. Whereas in the case of the environment, the outcome is not so obvious." [39] One understands him; *expanded art* had become for him the exterior face of his experiments with the *House.* He needed them; each new experiment breathed air into him, regenerated him; his response would always be different by virtue of being a specific adaptation.

There were the experiments with landscape. The entire garden plan for *Saint-Martin d'Hères,* 1978, was never brought to term by its backers, but it taught the artist that he had to pay attention to maintenance, that he could not abandon his creations to the vagaries of time and the whims of other people. He had to make his work self-protecting, to preserve its dimension of purity. This is what he did with the *Pot or monumental* [*Monumental Gold Flower Pot,*] 1985 *(fig. 34),* in the locked greenhouse at the Fondation Cartier. Intervening within the luxuriance of a park, he inverted the landscape by putting the concept of nature in a cage, but with such preciosity and delicacy!

The grand landscape would have been *Le Soleil noir,* [*Black Sun*] *(fig. 35) 1981,* a huge metal disk conceived for Flaine, to be anchored on a snowy crest in the Alps at an altitude of one-and-three-quarters miles. This melancholy sign, over the course of a year, would have shown the appearance and disappearance of light, and once a year would have caused a brief artificial solar eclipse. This need to inscribe man in the course of the stars, to identify humanity with the infinity of cosmic movement, was achieved in 1989 with the *La Carte du ciel* [*Sky Map*] *(fig. 36)* on the rooftop terrace of la Grande Arche at la Défense, 1,900 square yards of white marble and black granite: "In ancient civilizations, important edifices were laid out in relationship to the points of the compass. So I inscribed—after the fact, since the architecture had already been built—the precise orientation of the sky's map in the edifice by marking East, the zero degree of the sign of the Ram. Thus, this architecture resumed its true place in a spatial organization, and man then could

envisage, with somewhat more serenity, his foundation in space." [40]

Neither *Le Soleil noir* in Flaine nor the presentation of the *Gisants de Fontevrault* [*Effigies of Fontevrault*], 1985, was ever to be realized, for identical reasons: resistance to the display of the contemporary. At Fontevrault Abbey in the Loire Valley, Raynaud had intended a minimal intervention: four masterpieces of medieval sculpture, the recumbent figures, were to be presented as though floating in four subtly lighted, white ceramic graves. A twentieth-century harmony would have focused attention on these sacred works of the past whose original site had been forgotten. But contemporary man is not yet sufficiently mature to dare to imprint his vision and his sensibility on a natural site or a historical tradition. The reactions of nature lovers and professional historical preservationists clearly demonstrated that artistic interventions and contemporary signs were unwelcome in spaces that are being

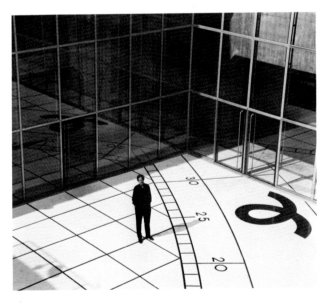

36. *La Carte du ciel* [*Sky Map*], La Grande Arche, La Défense, Paris, 1989

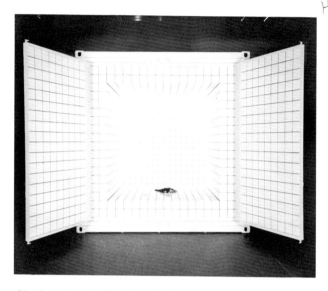

37. *Container zéro* [*Zero Container*], Musée national d'art moderne, Centre Georges Pompidou, Paris, 1988

38. *La Garenne-Colombes*, exterior view, 1989

massacred anyway and that men of all eras have sought to appropriate for themselves. Can the past have a reality if it is cut off from the present?

Begun in 1981 and finished in 1986, the *Jardin d'eau* [*Water Garden*] *(fig. 39)* in Monaco takes the form of a roofless house, a space of perspectives, of frames opening onto the Mediterranean horizon, whose use as a swimming pool guarantees its ongoing maintenance. At an opposite extreme from this seascape, yet also acting as a setting for speculation on the concept of representation, is the *Container zéro* [*Zero Container*], 1988 *(fig. 37)*, at the Musée national d'art moderne in Paris, which must be considered an on-site work: the revelation of an interior image within the very object of displacement. The Container is a jewel-box space for a contemplation "in progress," a suspension of time, a silence as prelude to encounters for which the artist remains responsible, for it is he himself who, according to his wishes, decides which creations from which periods will occupy this space that runs counter to the transparency and obligatory tours and brouhaha of the Pompidou Center: "The zero container is a remembrance of the *House,* its official echo in a museum . . . where I am going to rebuild all the art gestures from my house." Indeed, since the *House* is closed from now on, the container is its visible image, an index of the private adventures pursued there.

The *Container zéro* was inaugurated at the same time that Raynaud began work on *La Garenne-Colombes*, 1989: a kind of Mastaba that he was to make into his place of communication. This was where he would receive his friends and present his work. *La Garenne-Colombes* *(fig. 38)* is the inverse of the Saint-Cloud *House:* its tilework is on the outside, signaling its contents. In this space hollowed out below ground level, a sanctuary bathed in zenithal light, made of concrete and white gravel, the artist can install his movable works in an ideal setting, where the viewer's gaze is strategically led from the stark essentials to revelation.

Raynaud has made only one monument in the tradi-

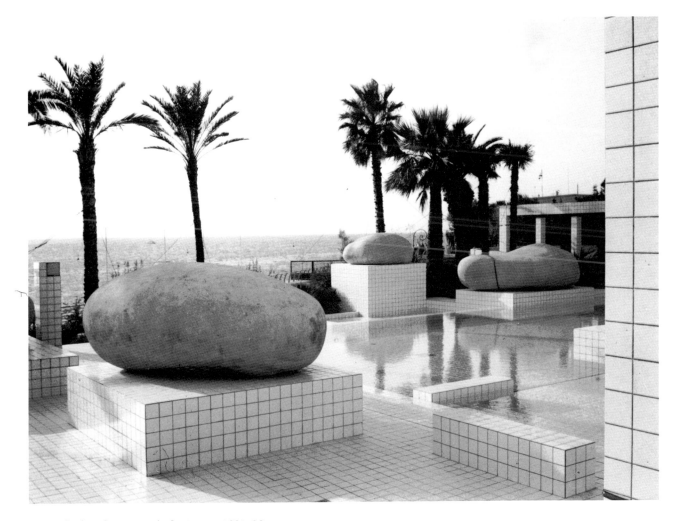

39. *Jardin d'eau* [*Water Garden*], Monaco, 1981–86

tional sense of the word, the *Stèle* [*Stela*], 1989, installed on the square of the Centre National de Recherches Scientifiques at the Quai d'Orsay in Paris, commemorating that organization's fiftieth anniversary. It is just as significant of his extremist and minimalistic approach, which leads him in his exhibition objects to interpret the real without modifying it to give it a meaning. The laboratory pallet upon which this molecule "stripper" is set was a Raynaud work, since it was tiled. Put flat on the wall, the pallet showed the machine disassembled in the same order as it was built, before becoming utilitarian. Stripped of its function, now an art work, it testified to the logic of its inherent coherence with a rare cruelty. Our world is one of violence, and all our objects bear witness to this.

In the Stela's Image

The shape that most often recurs in Raynaud's work is the stela. In public spaces it is always empty, naked. It appears at Saint-Martin d'Hères; it is used as a *Fontaine* [*Fountain*] at Oullins, 1986 *(fig. 40)*; its development becomes more complicated in Quebec's (*Autoportrait (Dialogue avec l'histoire)* [*Self-Portrait (Dialogue with History)*)], 1987 *(fig. 41)*, or in the *Stèle pour les Droits de l'Homme* [*Human Rights Monument*], 1990 *(fig. 43)* in Chicago; and it culminates at the Minguettes *(fig. 42)*, a project begun in 1984 that will be finished in 1991.

In Oullins, a place with no identity, Raynaud created a monumental, radical sign from which a community could recreate itself. The energy and the challenge of the sign are softened by the sound of rippling water, a moving mirror that captures light and clothes the material with life. In Quebec, the oldest city in North America, the artist sought to inscribe the twentieth century in a protected architectural space. Marble (material of Greek temples) was used instead of ceramic in order to emphasize historical continuity and adapt to the dimensions involved. The stela amplifies the "self-portrait" form already carried out in his studio: two pedestals, one on top of the other, slightly offset. Jean-Pierre Raynaud can communicate only after having experimented on himself, and within his deepest self, with each problem that he encounters. Modern man's image is found in the purification of proportions that Raynaud experiences in his solitary quest of the absolute. One must live in order to know the weight of life, cross boundaries in order to measure the price of freedom: "When one lives alone as I do, in such a serious way, death is inevitably part of the environment. Not death with its ghosts, but death that implies consciousness of time. This direction, this belonging to a particular time, not shared, in which one is given solely to oneself, may be a gesture of egoism insofar as introspection, if not echoed in the outside world, is doomed to failure. Highly accomplished art

40. *Fontaine* [*Fountain*], Oullins, 1986

works demonstrate that all strong introspections have nevertheless been a means of communication with other people.'' [41] Like that of the Cistercians, his attitude is oblational, but in a world deprived of God, it refers back to man.

The *Stèle pour les Droits de l'Homme* takes up the same problem again, giving back to the modern individual a consciousness of self with regard to other people, in a world for which one has complete responsibility: a stela with three pedestals on top, a *mysterium equilibrium* that can contain everything. The sculptor's goal is not to load space down "with more things" but to inscribe a meaningful presence there, a pure volume that resonates with the quest for freedom and awareness of the cosmic order. To manifest art in a consumer society that chases after time is also to dismantle the non-temporal in an age that has lost the notion of eternity. As for the Minguettes tower, it will be Jean-Pierre Raynaud's most monumental stela yet, as well as the tallest sculpture of our century. Along with other artists, Raynaud was called to intervene in Vénissieux—a suburban neighborhood of Lyons, a failure of postwar urban development, a theater of extremely violent social and racial confrontations—which sought rehabilitation through restructuring. Raynaud was challenged by the site, which immediately revealed to him his mode of intervention. Do not integrate; rather, sublimate. Since these sinister towers were soon to be demolished, let one be given to him! Refusing the idea that art was nothing but a whim "that would be accepted on the condition that it not be too imposingly present," he wanted to qualify the Minguettes site by doubly turning over its history. His tower will be the first sculpture to have had people living inside it, but at the same time it will stand as a gigantic stela whose purity will serve to exorcise the town's dramatic past, not by denying it but by recharging it with a positive energy. Eleven thousand square yards of white ceramic tile grouted with black cement will completely cover it, sealing the doors and windows. The artist's gesture has the sharpness of a

surgeon's: he does not erase history; he grafts hope onto its existing volume. Cathedral of a secular century, it is in no way a monument to the dead. It should appear like the sign of a city undertaking its own transformation.

For Jean-Pierre Raynaud, the stela is a beacon standing for difference, like a pyramid. Monolithic, it defines

41. *Autoportrait (Dialogue avec l'histoire)* [*Self-Portrait (Dialogue with History)*], Quebec, 1987

42. Minguettes, *La tour blanche*, maquette, Vénissieux, Lyons, 1984

an interior space distanced from circumstance and from the ephemeral by its proportions and by its material. It represents a zone of silence, a zero point of consciousness susceptible to the imaginary, a landing strip open to all virtualities.

Jean-Pierre Raynaud's stelae are so emblematic that no decorator has dared to subvert them. Their form and material are the result of a lived experience translated, to the very millimeter, into an order that is not mathematical but ruled by emotion: "One does not live perfection; one dreams it." The artist inscribes it in a synthetic space where past and present are reconciled through the absolute of the elementary. Raynaud rejoins Mondrian: "Today, pure beauty is not only something that we need, but it is the only medium manifesting in a pure way the universal force that is in all things. It is identical to

everything unveiled in the Past under the name of Divinity, which is indispensable to us, poor humans that we are, to live and to find Equilibrium, because things in and of themselves stand against us, and the most material world does battle with us." [42]

Geometry does not represent an imprisoning order; it is the ladder leading to the sublime. Raynaud respects the past too much to reproduce it; he may well rediscover universal shapes and forms, but he fills them with meanings that are different because relived. But because natural elements are disappearing, because we are transforming nature, he makes us reconsider it without being opposed to this transformation. Painting and sculpture ought no longer to be integrated into architecture; the concept of *expanded art* allows them to be integrated into reality itself, turning them into signs of an experience of the absolute. Creation is a moral act that entails going to the limits of the self to rediscover communicable universals.

For Jean-Pierre Raynaud, on-site intervention represents an encounter with a situation where something may take place. If he recognizes it, he encircles it, each experience encouraging a new adventure through its possibilities of reinventing the real. He does not seek, like the designer or the architect, to carry out a program. He must sign each one of his demonstrations with a work that exposes him in his radical quest for the essence of art. Creation, for him, is a new freedom to conquer, starting from point zero. It is by making his mark in a spatial field that modern man finds the means of materializing his spirituality. Jean-Pierre Raynaud subscribes to the necessity of the right angle because it is the image of contemporaneity, at odds with the natural environment. But "vision" does not precede realization. It is forged through experimentation with the real, something that only *expanded art* totally permits.

—*Translation by Karen C. Chambers Dalton and John Kaiser*

43. *Stèle pour les Droits de l'Homme*
[*Human Rights Monument*], Chicago, 1990

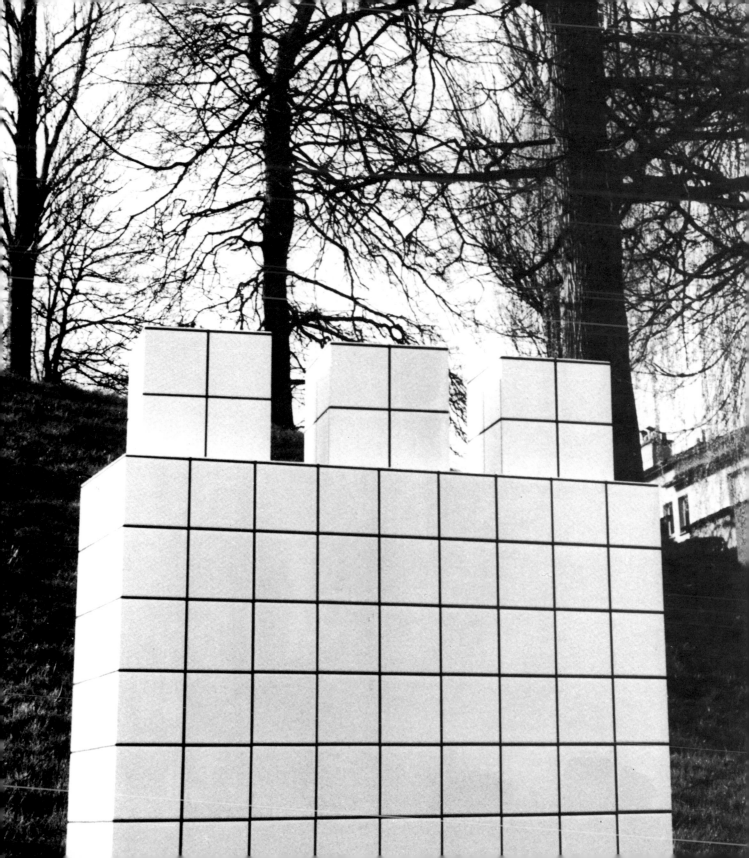

Notes

1. Interview with Raynaud by Maïten Bouisset, in Gladys C. Fabre and Georges Duby, *Jean-Pierre Raynaud* (Paris: Hazan, 1986), p. 128.

2. Although this article was prepared with the artist's collaboration following many discussions, it will give rise to only a few new citations of his words. Because the word, for Raynaud, expresses the depth of his thinking, he will use the same ideas and the same vocabulary to evoke past experiences, and many books over the past few years have already covered this.

3. "Malevitch, architectones" (Centre Georges Pompidou, 1980) and "L'atelier de Mondrian" (Staatsgalerie Stuttgart, 1980, and Macula, Paris, 1982) provided these artists' first approaches to working in three dimensions.

4. Walter Gropius, "Manifeste du Bauhaus," Weimar, 1919.

5. On this subject, see Jean-Luc Daval, "New Approaches That Challenge All Definitions and Theories," in *L'art et la ville: Town-Planning and Contemporary Art* (Geneva: Éd. Skira, 1990), p. 25.

6. Kasimir Malevitch, "De Cézanne au suprématisme" [1920], in *Ecrits I* (Lausanne: Éd. l'Age d'Homme, 1974), p. 121.

7. Kasimir Malevitch, "Notes sur l'architecture," *Carnet de notes III.* (Stedelijk Museum, Amsterdam: Andersen, 1978), vol. IV.

8. Kasimir Malevitch, "Suprématisme–architecture," Wesmuth, 1927.

9. Piet Mondrian, *De Stijl* (March 1922).

10. Piet Mondrian, "Le Home, la Rue, la Cité," *Vouloir*, no. 25, Lille (Jan.-Feb. 1927).

11. Rudolf Carnap, "Der Raum. Ein Beitrag zur Wissenschaftslehre in Kunststudienen," *Ergänzungsheft 56*, Berlin (1922).

12. Piet Mondrian, "Enquête sur l'art abstrait," *Cahiers d'art*, 7–8, Paris (1931).

13. See n. 5, particularly pp. 27–28.

14. Herbert Read, *Histoire de la sculpture moderne* (London: 1964).

15. Rosalind Krauss, quote in "Qu'est-ce que la sculpture moderne?," *MNAM*, Paris (1986). By the same author, see "Sculpture in the Expanded Field" in *The Originality of the Avant-Garde and Other Modernist Myths* (Cambridge: MIT Press, 1988), pp. 276–90.

16. Fabre, *ibid.* (see note 1), p. 23.

17. *Ibid.*, p. 17.

18. Jean-Pierre Raynaud, interview by J. H. Martin, *Art Press* no. 143, Paris (Jan. 1990).

19. Kasimir Malevitch, *Die Gegenstandlose Welt* [*The Objectless World*] (Munich: 1927).

20. Denyse Durand-Ruel, Yves Tissier, and Bernard Wauthier-Wurmser, *Jean-Pierre Raynaud, la Maison 1969–1987* (Paris: Éd. du Regard, 1988).

21. *Ibid.*, p. 29.

22. *Ibid.*, p. 41.

23. *Ibid.*, p. 43.

24. *Ibid.*, p. 75.

25. *Ibid.*, p. 74.

26. *Ibid.*, p. 93.

27. *Ibid.*, p. 143.

28. Conversation with the author, July 1990.

29. Denyse Durand-Ruel *et. al., ibid*, p. 143.

30. Georges Duby, *ibid.* (see note 1), p. 10.

31. Denyse Durand-Ruel *et. al., ibid*, p. 172.

32. *Ibid.*, p. 163.

33. *Ibid.*, p. 173.

34. *Ibid.*, p. 194.

35. *Ibid.*, p. 245.

36. *Ibid.*, p. 246.

37. Bouisset interview, *ibid.* (see note 1), p. 130.

38. *Ibid.*, p. 66.

39. Martin interview, *ibid.* (see note 18), p. 16.

40. Prospectus, SEM Tête Défense, 1989.

41. Martin interview, *ibid.* (see note 18), p. 13.

42. Mondrian, *ibid.* (see note 10).

WORKS IN THE EXHIBITION

1. *Sens + Sens,* 1962

2. *Alphabet pour adultes*, 1963

3. *Objet aux tessons,* 1963

4. *Psycho-Collages. Papier de deuil,* 1964

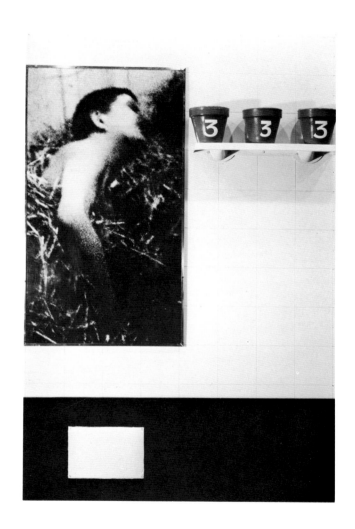

5. *Psycho-Objet 3 pots 3*, 1964

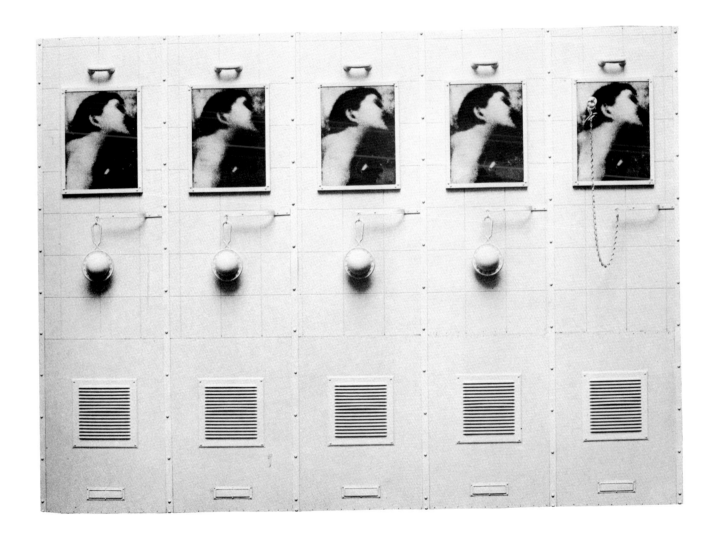

6. *Psycho-Objet 27 C. Le fou,* 1967

7. *Psycho-Objet 27. Visages censure*, 1967

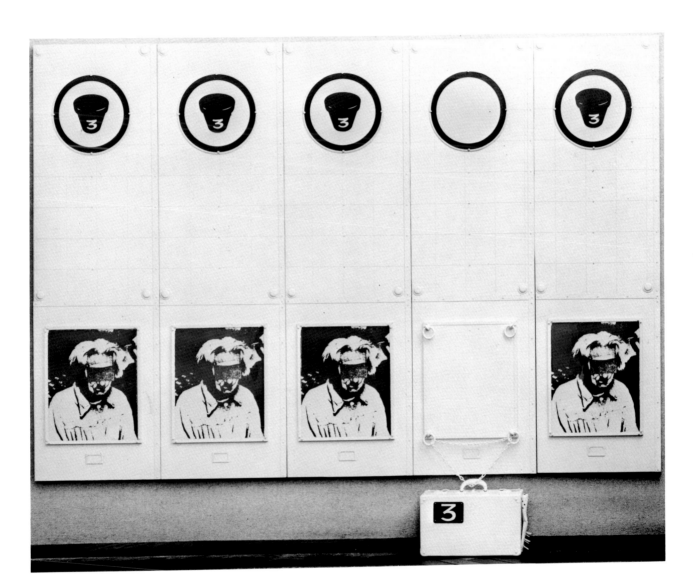

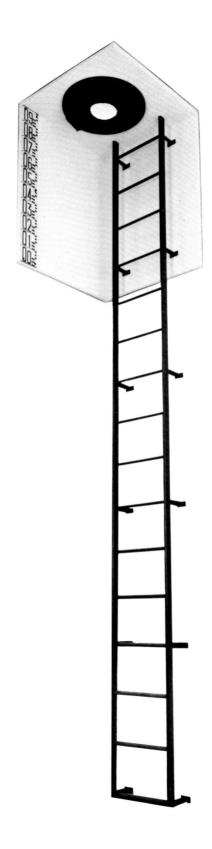

8. *Coin 806,* 1967

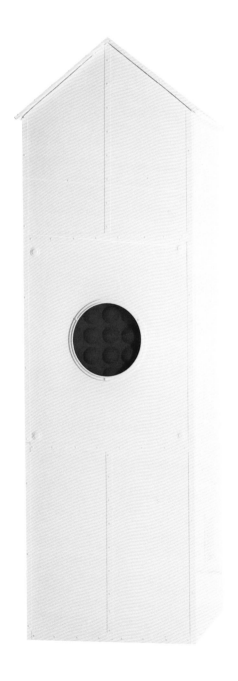

9. *Psycho-Objet 27 ans*, 1967

10. *Cuve aux cailloux blancs,* 1968

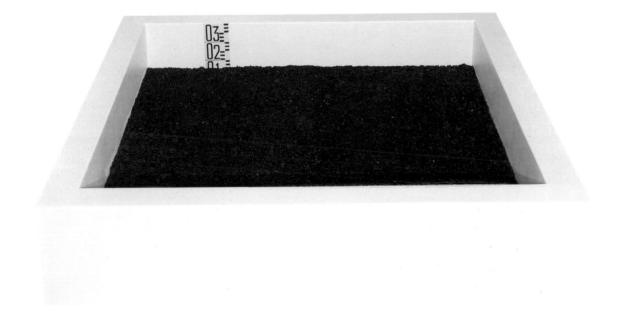

11. *Cuve au mâchefer,* 1968/89

12. *Pot 815,* 1968

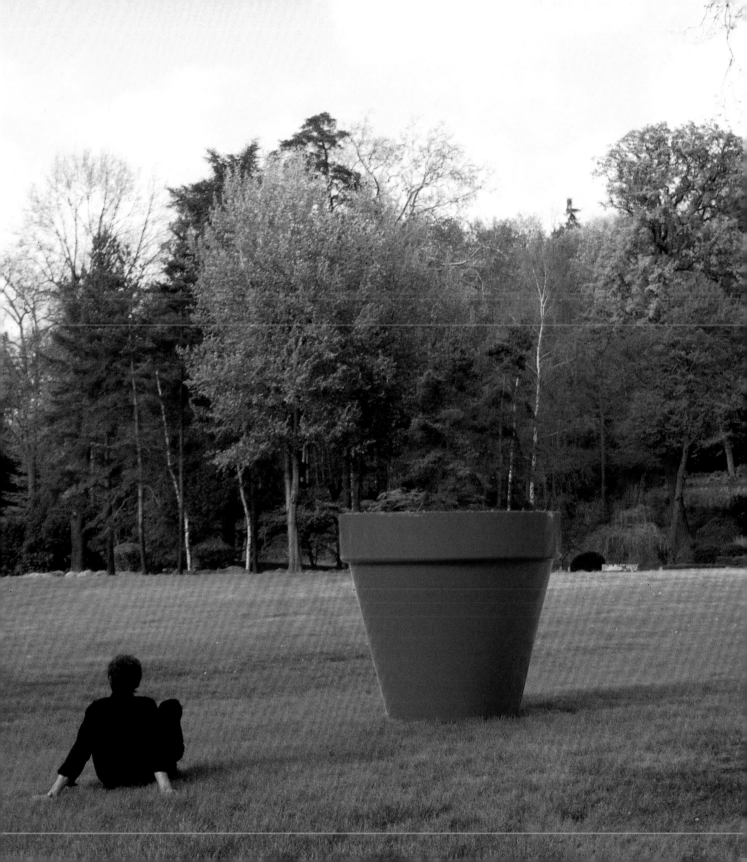

14. *Épure rouge cm 18* , 1970

13. *Mur P.V.C. 2000,* 1969

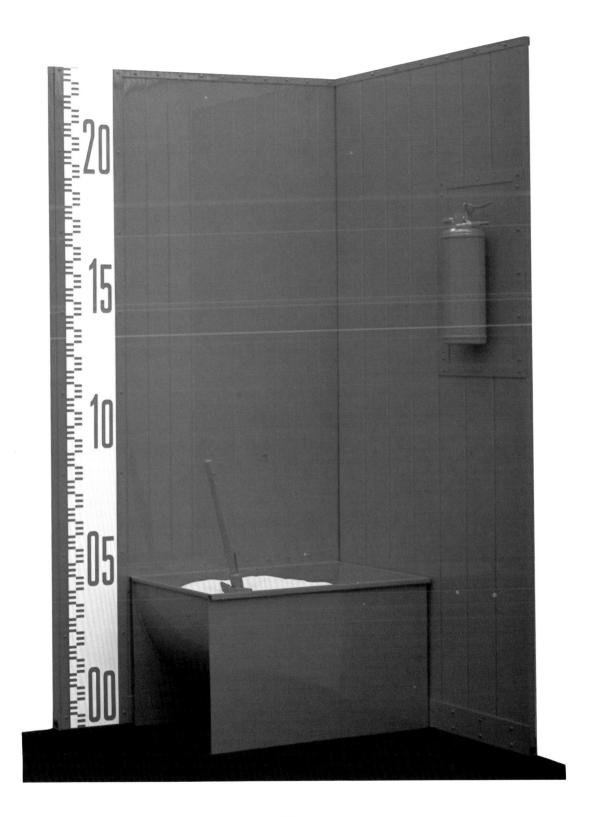

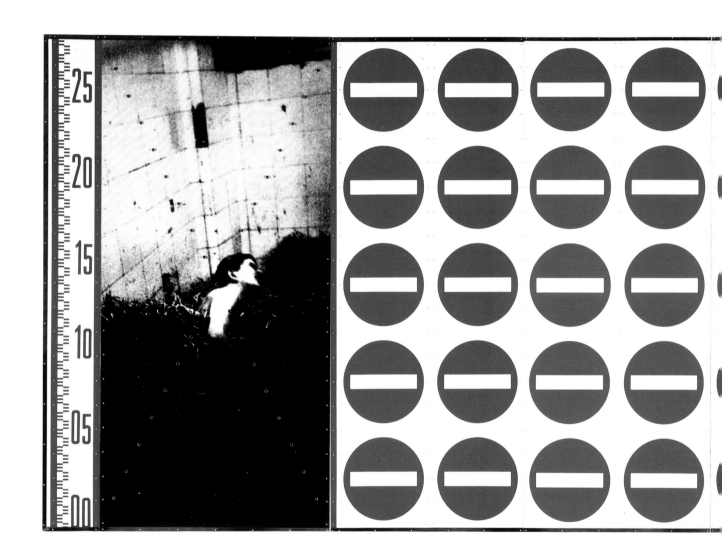

15. *Mur sens interdit (Grand collage papier + vis)*, 1970

16. *Cercueils modèle économique,* 1972

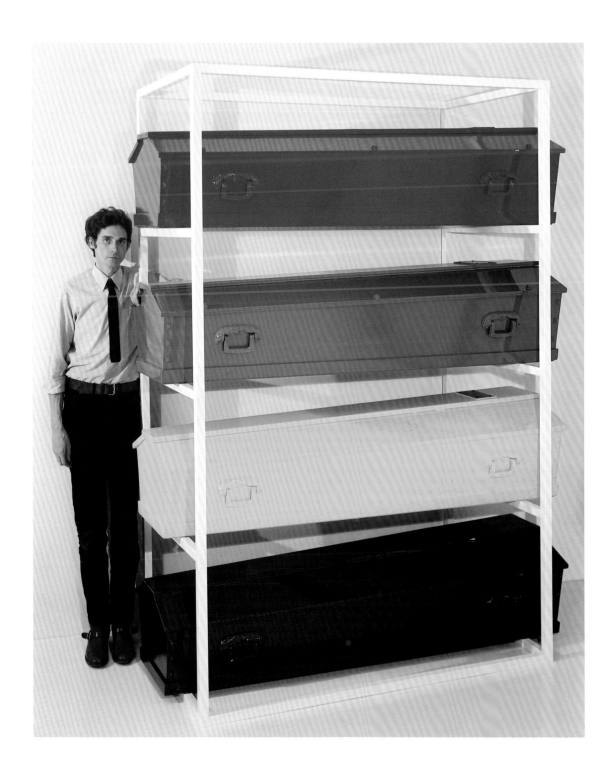

17. *Carrelage fleurs coupées,* 1974

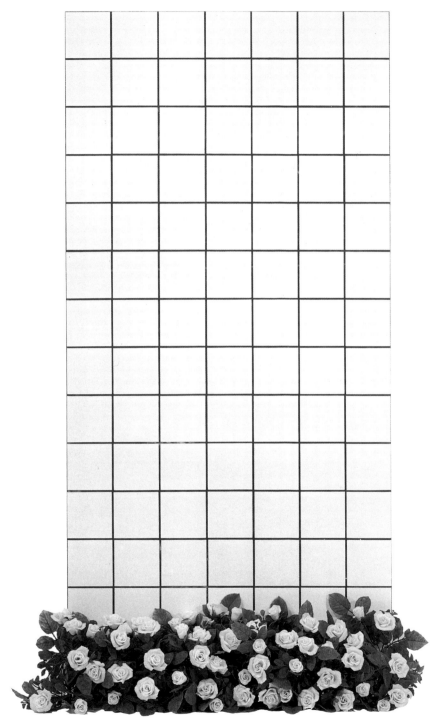

18. *Carrelage I,* 1974

19. *Espace zéro,* 1974 / 1983

20. *Fragment de la maison,* 1974

21. *Fragment de la maison,* 1974

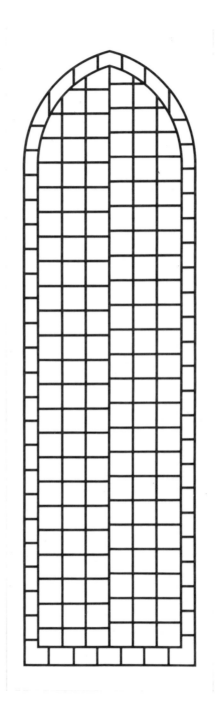

22. *Noirlac (vitrail) —*
Petite chapelle, 1976–77

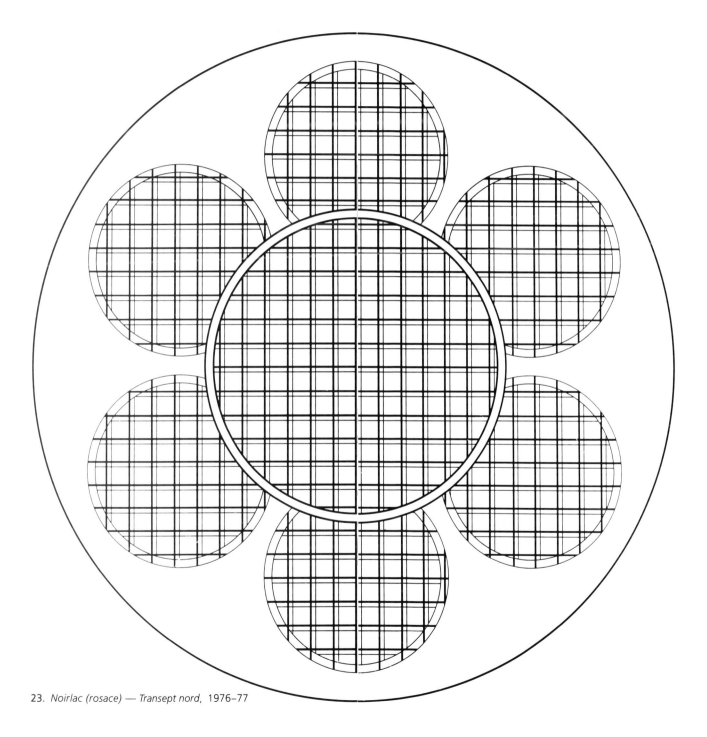

23. *Noirlac (rosace) — Transept nord,* 1976–77

24. *Autoportrait,* 1980 /1986

26. *Container + céramique,* 1985

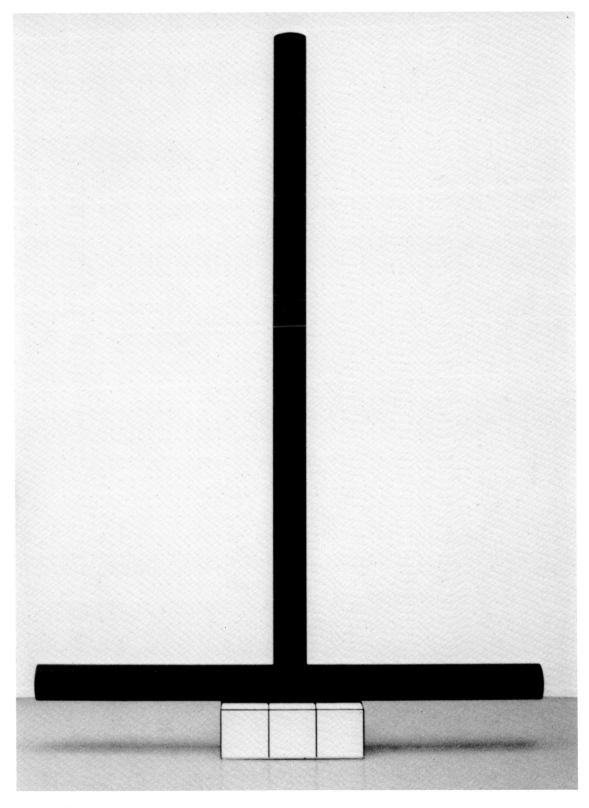

25. *Vertical + Horizontal II*, 1984

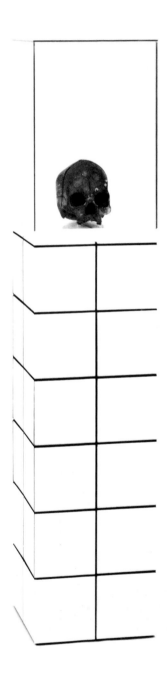

27. *Stèle + crâne néolithique,* 1985

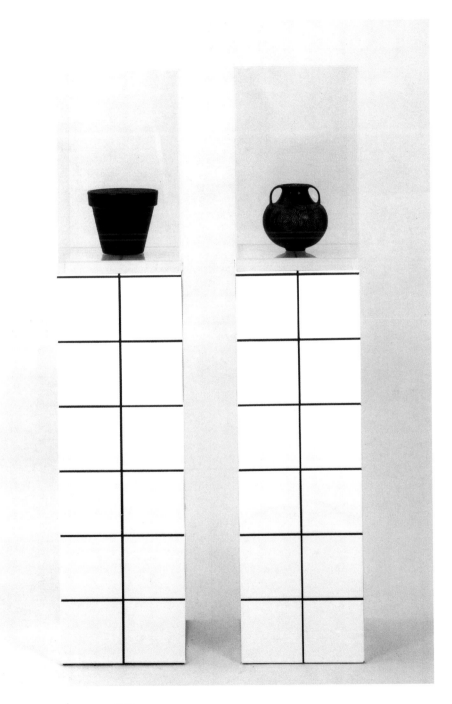

28. *Pot noir* + *Étrusque*, 1987

29. *Bleu Blanc Rouge,* 1987

30. *Poste de secours*, 1988

31. *Carrelage + radiographie,* 1989

32. *Pot noir* at La Garenne Colombes, 1989

33. *Stèle + Fers à béton,* 1989

34. *Carrelage + crochets*, 1990

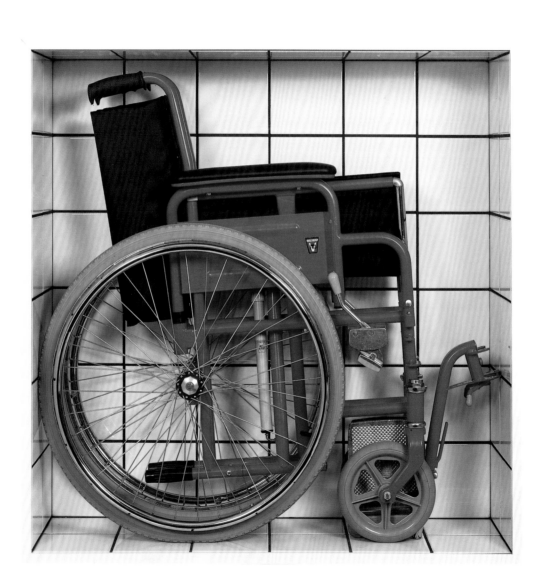

35. *Carrelage + siège roulant,* 1990

Works in the Exhibition

1. *Sens + Sens,* 1962
 [*Way + Way*]
 Paint on wood and metal, tileboard
 93³/₄ × 78³/₄ × 3¹/₂ in.
 238 × 200 × 9 cm
 Collection of the artist

2. *Alphabet pour adultes,* 1963
 [*Alphabet for Adults*]
 Paint on wood and iron
 85⁷/₁₆ × 23 × 4⁵/₁₆ in.
 217 × 58.5 × 11 cm
 Collection of the artist

3. *Objet aux tessons,* 1963
 [*Broken Bottle Object*]
 Paint on wood, glass shards
 37³/₈ × 44 × 6¹/₄ in.
 95 × 112 × 16 cm
 Collection of Philippe and Denyse Durand-Ruel,
 Rueil-Malmaison

4. *Psycho-Collages. Papier de deuil,* 1964
 [*Psycho-Collages. Mourning Stationery*]
 Printed stationery, envelopes, on layout mats
 Six units: 19¹¹/₁₆ × 13³/₁₆ in., each
 Six units: 50 × 33.5 cm, each
 Collection of Emmy de Martelaere, Paris

5. *Psycho-Objet 3 pots 3,* 1964
 [*Psycho-Object 3 Flower Pots 3*]
 Mounted photograph on tileboard;
 painted wood, terra cotta pots, metal
 72⁷/₈ × 48¹³/₁₆ × 9 in.
 185 × 124 × 23 cm
 Musée national d'art moderne,
 Centre Georges Pompidou, Paris

6. *Psycho-Objet 27 C. Le fou,* 1967
 [*Psycho-Object 27 C. The Madman*]
 Mounted photographs on tileboard with
 painted metal hardware
 66¹⁵/₁₆ × 94¹/₂ in.
 170 × 240 cm
 Museum Van Hedendaagse Kunst, Ghent

7. *Psycho-Objet 27. Visages censure,* 1967
 [*Psycho-Object 27. Censored Faces*]
 Photographs, enameled plaques on painted wood and
 tileboard with metal hardware and painted suitcase
 83¹/₂ × 122 in.
 212 × 310 cm
 Stedelijk Museum, Amsterdam

8. *Coin 806,* 1967
 [*Corner 806*]
 Painted steel ladder, enameled metal,
 and molded plastic on painted wood
 157¹/₂ × 29¹/₂ × 29¹/₂ in.
 400 × 75 × 75 cm
 The Museum of Modern Art, New York

9. *Psycho-Objet 27 ans,* 1967
 [*Psycho-Object 27 Years*]
 Painted wood and metal, plastic, plexiglas
 99⁵/₈ × 29¹⁵/₁₆ × 33 in.
 253 × 76 × 84 cm
 Collection of the artist

10. *Cuve aux cailloux blancs,* 1968
 [*Vat with White Pebbles*]
 Polyester resin, pebbles, enameled metal
 15³/₄ × 78³/₄ × 78³/₄ in.
 40 × 200 × 200 cm
 Collection of the artist

11. *Cuve au mâchefer,* 1968/89
 [*Vat with Coal Slag*]
 Polyester resin, coal slag, enameled metal
 15³/₄ × 78³/₄ × 78³/₄ in.
 40 × 200 × 200 cm
 Collection of the artist

12. *Pot 815,* 1968
 [*Flower Pot 815*]
 Polyester resin
 70⁷/₈ × 76³/₄ in.
 180 × 195 cm
 Collection of the artist

13. *Mur P.V.C. 2000,* 1969
 [*P.V.C. Wall 2000*]
 Painted polyvinyl chloride plastic, fire extinguisher
 and shovel, vinyl, sand
 94$\frac{1}{2}$ × 52$\frac{3}{4}$ × 29$\frac{1}{8}$ in.
 240 × 134 × 74 cm
 Private collection, Paris

14. *Épure rouge cm 18,* 1970
 [*CM 18 Red Diagram*]
 Vinyl on paper, paint
 39$\frac{3}{8}$ × 25$\frac{3}{4}$ in.
 100 × 65.4 cm
 Collection of Mr. and Mrs. Preston Bolton, Houston

15. *Mur sens interdit (Grand collage papier + vis),* 1970
 [*One-Way Wall (Large paper collage + screws)*]
 Photographs and ink on paper and vinyl, mounted
 under plexiglas on wood with screws and metal
 114$\frac{1}{2}$ × 344 in.
 291 × 873 cm
 Collection of the artist

16. *Cercueils modèle économique,* 1972
 [*Economy Model Coffins*]
 Painted wood coffins, metal frame
 95$\frac{1}{8}$ × 70$\frac{7}{8}$ × 30$\frac{5}{16}$ in.
 241.5 × 180 × 77 cm
 Collection of the artist

17. *Carrelage fleurs coupées,* 1974
 [*Tilework with Cut Flowers*]
 Ceramic tile on wood, cut artificial flower stems
 31 × 25 × 3$\frac{7}{8}$ in.
 79 × 63.5 × 10 cm
 Collection of Laurence de Ganay, Paris

18. *Carrelage I,* 1974
 [*Tilework I*]
 Ceramic tile on wood, artificial flowers
 80 × 43$\frac{5}{16}$ × 7$\frac{7}{8}$ in.
 203 × 110 × 20 cm
 Private collection, Paris

19. *Espace zéro,* 1974/83
 [*Zero Space*]
 Ceramic tile on wood, metal tag
 30$\frac{7}{8}$ × 24$\frac{7}{8}$ × 1$\frac{1}{4}$ in.
 78.6 × 63 × 3 cm
 The Menil Collection, Houston

20. *Fragment de la maison,* 1974
 [*Fragment from the House*]
 Ceramic tile on concrete
 30$\frac{5}{16}$ × 23$\frac{1}{4}$ × 4$\frac{3}{4}$ in.
 77 × 59 × 12 cm
 Collection of the artist

21. *Fragment de la maison,* 1974
 Ceramic tile
 15$\frac{1}{2}$ × 15$\frac{3}{16}$ × 2 in.
 39.5 × 38.5 × 5 cm
 Collection of Philippe and Denyse Durand-Ruel,
 Rueil-Malmaison

22. *Noirlac (vitrail) — Petite chapelle,* 1976–77
 [*Noirlac (stained-glass window) — Small Chapel*]
 India ink and pencil over acrylic on canvas
 92$\frac{1}{4}$ × 29$\frac{1}{2}$ in.
 234.2 × 74.9 cm
 The Menil Collection, Houston

23. *Noirlac (rosace) — Transept nord,* 1976–77
 [*Noirlac (rose window) — North Transept*]
 India ink and pencil over acrylic on canvas
 123$\frac{1}{4}$ × 123$\frac{1}{4}$ in.
 313 × 313 cm
 Fonds Régional d'Art Contemporain, Picardie

24. *Autoportrait,* 1980/86
 [*Self-Portrait*]
 Ceramic tile on wood
 71$\frac{5}{16}$ × 26 × 26 in.
 181 × 66 × 66 cm
 Collection of the artist

25. *Vertical + Horizontal II,* 1984
 Painted metal pipe, ceramic tile on wood
 137 × 96 in. (pipes), 9$\frac{7}{16}$ × 26$\frac{3}{4}$ × 26$\frac{3}{4}$ in. (pedestal)
 348 × 244 cm (pipes), 24 × 68 × 68 cm (pedestal)
 Musée d'Art moderne de la Ville de Paris

26. *Container + céramique,* 1985
[*Barrel + ceramic*]
Ceramic tile, painted metal barrel
39⁹/₁₆ × 23 in. (drum), ³/₄ × 43¹¹/₁₆ × 43¹¹/₁₆ in. (base)
91.5 × 58.5 cm (drum), 111 × 111 cm (base)
Collection of the artist

27. *Stèle + crâne néolithique,* 1985
[*Stela + Neolithic Skull*]
Ceramic tile on wood, plexiglas, neolithic skull
55¹/₂ × 12 × 12 in.
141 × 30.5 × 30.5 cm
Collection of the artist

28. *Pot noir + Étrusque,* 1987
[*Black Flower Pot + Etruscan Pot*]
Ceramic tile on wood, plexiglas; painted terra cotta
 pot filled with cement; terra cotta pot
55¹/₂ × 12 × 12 in., each
141 × 30.5 × 30.5 cm, each
Private collection, Paris

29. *Bleu Blanc Rouge,* 1987
[*Blue White Red*]
Cloth flag, ceramic tile on wood
78³/₄ × 104³/₄ in.
200 × 266 cm
Collection of the artist

30. *Poste de secours,* 1988 (illustrated)
[*First Aid Station*]
Ceramic tile on wood, glass, enameled metal
26 × 26 × 3¹/₁₆ in.
66 × 66 × 8 cm
Collection Galerie Daniel Templon, Paris

Carrelage + poste de secours, 1988/91 (exhibited)
[*Tilework + First Aid Sign*]
Ceramic tile, enameled metal
91⁷/₁₆ × 91⁷/₁₆ (wall); 41³/₈ × 41³/₈ (sign)
232 × 232 cm (wall), 105 × 105 cm (plaque)
Collection of the artist

Note: Catalogue numbers 30, 31, and 34 are special installations created for this exhibition. Comparable works are illustrated in the plate section. Complete entries are given for each version.

31. *Carrelage + radiographie,* 1989 (illustrated)
[*Tilework + X-ray*]
Ceramic tile on aluminum, light box, X-ray
19³/₄ × 18 × 59¹/₈ in. (x-ray), 36¹/₂ × 30⁵/₁₆ × 7¹/₄ in. (wall)
50 × 46 × 15 cm (x-ray), 92.5 × 77 × 3.5 cm (wall)

Carrelage + radiographies, 1991 (exhibited)
[*Tilework + X-rays*]
Ceramic tile, light boxes, X-rays
30⁵/₁₆ × 219¹³/₁₆ × 7¹/₄ in. (wall)
77 × 558 × 18.5 cm (wall)
Both versions collection of the artist

32. *Pot noir,* 1989
[*Black Flower Pot*]
Painted polyester resin
70⁷/₈ × 76³/₄ in.
180 × 195 cm
Collection of the artist

33. *Stèle + Fers à béton,* 1989
[*Stela + Irons in Concrete*]
Ceramic tile on wood, iron, concrete
93³/₁₆ × 30¹/₂ × 6¹¹/₁₆ in.
236.5 × 77.5 × 17 cm
Collection of the artist

34. *Carrelage + crochets,* 1990 (illustrated)
[*Tilework + Hooks*]
Ceramic tile, chromium-plated metal hooks
 on aluminum
19¹⁵/₁₆ × 18¹/₈ × 3¹/₂ in.
49 × 46 × 9 cm
Collection of Yannick Bideau, Paris

Carrelage + crochets, 1991 (exhibited)
[*Tilework + Hooks*]
Ceramic tile, chromium-plated metal hooks
19⁵/₁₆ × 115¹³/₁₆ × 3¹/₂ in.
49 × 294 × 9 cm
Collection of the artist

35. *Carrelage + siège roulant,* 1990
[*Tilework + Wheelchair*]
Ceramic tile on wood, wheelchair, glass
38³/₈ × 38 × 13⁷/₁₆ in. (box)
97.5 × 96.5 × 34.5 cm (box)
Collection of the artist

Chronology

1939
Born April 20, in Courbevoie, a suburb of Paris.

1943
His father's death, during a bombing.

1958
Graduates from the Ecole d'horticulture in Versailles.

1959
Military service in Paris.

1962
Makes his earliest works, re-using objects scavenged from the Gennevilliers city dump.

Begins the Sens Interdits series made with found wood, as well as the series of flower pots painted red and filled with concrete .

Discovers the works of Yves Klein, Daniel Spoerri, Raymond Hains, and Jean Tinguely at the Galerie "J" in Paris.

1963
Completion of his *Alphabet pour adultes*.

1964
First appearance of tileboard in his work.

Earliest *Psycho-Objets* (constructions of found objects painted white or red, employing photographs).

First group exhibition: Salon de la Jeune Sculpture, Paris.

1965
Construction of the *Psycho-Objet Maison* (summarizing and resuming all his previous *Psycho-Objets*).

First one-person show in Paris at the Galerie Jean Larcade.

1966
First *Autoportrait* [*Self-Portrait*].

Participation in the Prix Marzotto in Italy.

1967
Construction of *Psycho-Objet Tour* [*Psycho-Object Tower*] (14 ft. 9 in. high).

Begins series of works including Corners, Walls, and Gauges.

Travels to Brazil, where he takes part in the São Paulo Biennale; later, visits New York.

Beginning of the Red Period.

1968
Returning to Europe, makes his first presentation at the Düsseldorf Kunsthalle of a multiple installation of red flower pots (300), acquired by the Musée de Krefeld on the day of the exhibition opening.

Completion of his first monumental flower pot (5 ft. 11 in. high), made of polyester resin. An important one-person exhibition, organized by Pontus Hulten and Edy de Wilde (Stockholm, Amsterdam, Stuttgart, and Paris).

Purchase of real estate in La Celle-Saint-Cloud for the construction of a house.

Completion of an environmental installation at the home of Jean-Marie Rossi.

1969
Construction begins on the *House*.

First use of ceramic tilework with black grouting.

1970
First use in the *House* of pure white ceramic tiling, in 15 x 15 cm squares.

Construction of a wall in the home of Denyse and Philippe Durand-Ruel.

Coin 806 acquired by The Museum of Modern Art, New York.

Has 4,000 red flower pots manufactured in a factory.

1971

Installation exhibition of the 4,000 red flower pots in London, Jerusalem, and Hanover.

End of the Red Period.

1972

Beginning of the Red-Green-Yellow-Blue Period.

1973

Reworks *House* interior, gradually closing off all windows and doors.

1974

March 6–9, opening of the *House* to the public; on March 15 the exterior of the *House,* which had increasingly come to resemble a military bunker, is painted a khaki color.

First series of numbered white tile "paintings."

Completion of Bernard Ceysson's commission, the artist's first *Espace zéro,* for the Musée d'Art moderne, St. Etienne.

Installation of Didier and Martine Guichard's apartment entranceway.

1975

In April the *House* exterior is painted white again; inside, the floors are covered in white tile, like the walls and ceiling.

Beginning of the *Occultation* series.

1976

Completion of sixty-two stained-glass windows (fifty-five vertical windows and seven rose windows) in the Cistercian abbey at Noirlac, in Cher, France.

Completion of a tombstone in Saint-Ouen cemetery.

Represents France in the Venice Biennale, exhibiting a series of his numbered ceramic tile "paintings."

1977

Installation in Saint-Martin d'Hères, near Grenoble, of a 5,000-square-meter garden where ceramic tiling is used in association with landscape.

Inauguration of the Noirlac stained-glass windows.

Travels to Turkey: encounters oriental tilework.

1978

Travels to Afghanistan.

1979

Remodeling and renovations inside the *House.*

Travels to Spain.

1980

Receives a commission for a colored stained-glass window for the conference room of the Grenoble Préfecture.

Completion of a ceramic *Autoportrait* for a public garden in Lyons.

First flower pots covered in gold leaf.

1981

Extended stay in Japan, occasioned by a one-person exhibition in Tokyo, where he completes a total transformation of a gallery in the Hara Museum into an *Espace zéro.*

Plans for a monumental sculpture, *Le Soleil noir,* for Flaine, a ski resort in Upper Savoy.

Conception and completion of the *Jardin d'eau* in Monaco.

1982

New remodeling and renovations inside the *House.*

1983

Takes part, along with the architect Jacques Gourvennec, in an international competition to redo the Parc de la Villette by proposing a vegetational pyramid, which wins one of the nine first prizes *ex æquo.* Wins the Grand Prix national de la Sculpture.

1984

Completion of an *Espace zéro* for the entrance to "La Rime et la Raison" (exhibition of the Menil family collection) at the Grand Palais, Paris.

Completion of an opaque ceramic stained-glass window for the Romanesque church in Charenton-sur-Cher.

First *Tableaux barrés* [paintings with black vertical stripes].

Commission for a ceramic-tiled house in the Vexin (construction permission denied by the town zoning commission).

Completion of an environment for the stall of the Galerie de France at the FIAC in Paris.

A study of the *House* is undertaken by architects Yves Tissier and Bernard Wauthier-Wurmser for the Bureau of Architectural Research of the Ministère de l'Equipment, du Logement, et de l'Aménagement du territoire.

1985

The Cartier Foundation for Contemporary Art (in Jouy-en-Josas, near Paris) mounts an important exhibition of Raynaud's work. For the occasion, he installs a monumental sculpture in the Foundation garden: a large gold-gilded flower pot enshrined in a greenhouse.

Travels to Italy, where he visits Etruscan excavation sites.

In France, impassioned polemics against him are provoked by his planned installations for Vénissieux and Fontevrault.

Wins the Prix Robert Giron in Brussels.

1986

Completion of ceramic fountain, *Fontaine* (6 ft. 6 in. high), in Oullins, near Lyons.

A sculpture for the Hôtel des Finances in Créteil (near Paris) is commissioned.

Presentation of his plans for the *Tour des Minguettes* (for Vénissieux, a Lyons suburb) at the colloquium "Art and the City: Urbanism and Contemporary Art" held in Paris at the Palais du Luxembourg.

Permanent installation of 1,000 red flower pots in an antique greenhouse in the sculpture garden at the Kerguehennec Château.

Wins the Grand Prix de Sculpture de la Ville de Paris.

1987

Beginning of the Blue-White-Red series.

Completion of a monumental *Autoportrait* for the city of Quebec.

1988

Completion of his *Espace zéro,* entitled *Container zéro,* on-site at the Georges Pompidou Center, Paris.

Presentation, at the Galerie Jeanne Bucher in Paris, of a book about the *House,* published by Editions du Regard.

September 1, closing of the *House* to the public until the year 2008.

1989

Conception and completion of *La Carte du ciel* (1,900 square yards of white marble and black granite) on the rooftop terraces of the Grande Arche à la Défense in Paris.

Installation in the municipal council chamber of Villeurbanne City Hall, in the Rhône, of a large *Drapeau libre* [*Free Flag*].

Construction, for his personal exhibition space, of a 350-square-yard exhibition and storage building, half of which is underground, in La Garenne-Colombes, a suburb of Paris.

Commission for a sculpture to commemorate the fiftieth anniversary of the CNRS (Centre national de la recherche scientifique).

1990

October: Inauguration of the *Stèle pour les Droits de l'Homme* [*Human Rights Monument*], a gift by the French government to the Museum of Contemporary Art—Chicago.

1991

Retrospective exhibition travels to Houston, Chicago, and Montreal.

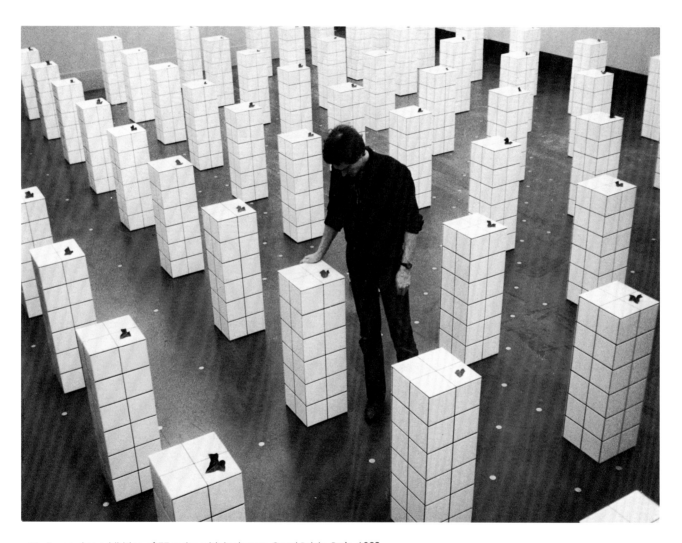

44. Raynaud at exhibition of 77 stelae with ivy leaves, Grand Palais, Paris, 1983

Exhibitions

One-Person Exhibitions

1965
Paris, Galerie Jean Larcade, "Les Objecteurs," with catalogue text by Alain Jouffroy.

1966
Paris, Galerie Mathias Fels, "Psycho-Objets," with catalogue text by Pierre Restany.

1967
Milan, Galerie Apollinaire.

1968
Paris, Galerie Mathias Fels, "L'Espace en situation."

Stockholm, Moderna Museet; with catalogue text by Jean-Pierre Raynaud.

Amsterdam, Stedelijk Museum.

Stuttgart, Württembergischer Kunstverein.

1969
Paris, CNAC [Centre national d'art contemporain].

Paris, Galerie Alexandre Iolas, "La Réalité au mètre."

Paris, Hôtel Georges V.

1970
Brussels, Palais des Beaux-Arts.

New York, Alexandre Iolas Gallery, Paris, Galerie Alexandre Iolas; with catalogue.

1971
London, Serpentine Gallery, "4,000 Pots."

Jerusalem, Israel Museum, "4,000 Pots," with catalogue texts by Yona Fischer and Jacques Caumont.

Hanover, Rathaus, "4,000 Pots."

Brussels, New Smith Gallery.

1972
Paris, Musée des Arts décoratifs, "Rouge, Vert, Jaune, Bleu," with catalogue text by François Mathey, including a transcribed conversation between Jean-Pierre Raynaud and Pierre Sterckx.

Turin, Galerie LP 220.

Brussels, Galerie d, with catalogue.

Milan, Galleria Annunciata.

1973
Paris, Galerie Alexandre Iolas, "Funéraires."

1974
Paris, Galerie Alexandre Iolas, with catalogue.

Brussels, Galerie d, with catalogue.

1975
Paris, Galerie Alexandre Iolas, "Œuvres récentes."

Brussels, Palais des Beaux-Arts, "Panorama sur douze ans," with catalogue text by Pierre Sterckx, plus an interview with the artist by Marian Verstraeten.

1976
Venice, French pavilion at the Biennale.

1978
Ghent, Museum van Hedendaagse Kunst, with catalogue text by Jan Hoet.

1979
Paris, Centre Georges Pompidou, Musée national d'art moderne, "Raynaud 1974–1978," with catalogue text by Pontus Hulten.

Paris, Galerie Nancy Gillespie/Elizabeth de Laage, "Expérience pour une fenêtre."

1981
Paris, Galerie Jean Fournier.

Tokyo, Hara Museum of Contemporary Art, with catalogue texts by Toshio Hara and Pierre Restany.

Rio de Janeiro, Café des Arts at the Hôtel Méridien.

1982
Coutances, Galerie l'Hermitte.

1984
Zurich, Galerie Daniel Varenne (Forum), with catalogue.

Paris, Galerie de France (FIAC [Foire internationale d'art contemporain]).

Los Angeles, Newport Harbor Art Museum, with catalogue texts by Paul Schimmel and Jean de Loisy.

1985
Paris, Galerie Gilbert Brownstone, "Murs barrés."

Paris, Musée d'art moderne de la Ville de Paris, ARC, "Noir et Blanc," with catalogue texts by Suzanne Pagé and Bernard Marcadé.

Chicago, Galerie Daniel Varenne (International Art Exposition), with catalogue.

Jouy-en-Josas, Cartier Foundation for Contemporary Art, "Raynaud – Archétypes," with catalogue texts by Marie-Claude Beaud, Maïten Bouisset, and Guy Tosatto.

1986
New York, Carpenter + Hochman Gallery, with catalogue text by Jean-Pierre Raynaud.

Paris, Galerie Daniel Varenne (FIAC).

Los Angeles, Wenger Gallery.

1988
Paris, Galerie de France, "Bleu, Blanc, Rouge."

1989
Villeurbanne, Galerie de l'Hôtel de Ville, "1962–1989," with catalogue.

Paris, Galerie Carré (FIAC).

1990
Düsseldorf, Galerie 44.

1991
Houston, The Menil Collection, with catalogue texts by Walter Hopps, Alfred Pacquement, and Jean-Luc Daval; traveling to the Museum of Contemporary Art–Chicago and the Centre international d'art contemporain de Montréal.

New York, Leo Castelli Gallery.

New York, Sonnabend Gallery.

Principal Group Exhibitions

1964
Paris, Galerie Creuze, Salon de la Jeune Sculpture.

Paris, Musée d'Art moderne de la Ville de Paris, Salon Comparaisons.

Paris, Musée d'Art moderne de la Ville de Paris, "Mythologies quotidiennes."

1965
Paris, Galerie Creuze, "Groupe international."

Paris, Musée d'Art moderne de la Ville de Paris, Salon de la Jeune Peinture.

Paris, Galerie Ranelagh, "La Leçon de choses."

Paris, Musée d'Art moderne de la Ville de Paris, Salon Comparaisons.

Paris, Musée Rodin, Salon de la Jeune Sculpture.

Paris, Galerie Jean Larcade, "Pop por Pop Corny."

Paris, Musée d'Art moderne de la Ville de Paris, 4th Biennale.

1966
Paris, Galerie Mathias Fels, "Accrochage 66."

Paris, Musée d'Art moderne de la Ville de Paris, Salon de Mai.

Paris, Musée d'Art moderne de la Ville de Paris, Salon de la Jeune Peinture.

Paris, Musée d'Art moderne de la Ville de Paris, Salon Comparaisons.

Valdagno (Italy), Prix Marzotto (exhibition touring Europe).

1967
São Paulo, 9th Biennale.

Paris, Musée d'Art moderne de la Ville de Paris, Salon de Mai.

Paris, Musée d'Art moderne de la Ville de Paris, 5th Biennale.

1968
Paris, Galerie Mathias Fels, ''L'Espace en situation.''

Düsseldorf, Kunsthalle, ''Prospect 68.''

Paris, Musée d'Art moderne de la Ville de Paris, Salon de Mai.

Saint-Paul-de-Vence, Maeght Foundation, ''L'Art vivant.''

Paris, New York, Washington, Chicago, Atlanta, Dayton, ''Peintres européens d'aujourd'hui.''

Eindhoven, Stedelijk von Abbemuseum, ''Three Blind Mice.''

1969
Marseilles, Musée Cantini, ''Naissance d'une collection.''

Saint-Germain-en-Laye, Musée municipal, ''Depuis Rodin.''

1970
Lausanne, Musée des Beaux-Arts; Paris, Musée d'art moderne de la Ville de Paris, 3rd Salon international des Galeries pilotes.

Knokke-le-Zoute, casino, 23rd Belgian Summer Festival.

1971
Brussels, Palais des Beaux-Arts; Rotterdam, Berlin, Milan, Basel; and Paris, Musée des Arts décoratifs, ''Métamorphose des Dinges.''

Lisbon, Gulbenkian Foundation, ''Art français depuis 1950.''

1972
New York, Solomon R. Guggenheim Museum, ''Amsterdam, Paris, Düsseldorf.''

Paris, Grand Palais, ''Douze Ans d'Art contemporain en France.''

1977
European touring exhibition (Paris, Chapelle de la Sorbonne), ''Handwerk und Kirche.''

1980
Lyons, 2nd Symposium on Sculpture.

New York, Espace Cardin, ''Cent Peintres de Paris, 1950–1980.''

Belgrade, Musée d'Art moderne, ''Exposition internationale des Arts plastiques.''

1981
Toyama (Japan), Museum of Modern Art.

1983
Paris, Grand Palais, ''Damian + Raynaud.''

Paris, Centre Georges Pompidou, exhibition of prize-winning entries from an international competition to redo the Parc de la Villette.

Paris, Pavilion des Arts, ''Une journée à la campagne.''

1984
Paris, Grand Palais, ''La Rime et la Raison, les collections de Menil.''

Ivry-sur-Seine, ''Peinture non plane en France d'aujourd'hui.''

Paris, Musée des Arts décoratifs, ''Sur invitation.''

Tokyo, Seibu Museum.

1986
Paris, Galerie Jeanne Bucher, ''Questions d'urbanité.''

1987
Paris, Centre Georges Pompidou, Musée national d'art moderne, ''L'Epoque, la Mode, la Morale, la Passion.''

1989
Paris, Galerie Urban, ''Architectures.''

Moscow, Leningrad, ''L'Art en France, un siècle d'inventions.''

1990
Japan, touring exhibition about contemporary art and urbanism in France.

Warsaw, Crakow, group exhibition.

Fréjus, Daniel Templon Foundation, Musée temporaire, ''L'Art en France, 1945–1990.''

Bibliography

Books about Jean-Pierre Raynaud

Jacques Caumont, *Raynaud*. Paris: Editions Galerie Rive Droite, 1970.

Dominique Chenivesse, *La Maison de Raynaud*. Paris: Mémoire de fin d'études de l'ICART, 1974.

Demosthenes Davvetas, *Jean-Pierre Raynaud, La Garenne-Colombes*. (Translated from Greek to French by Xavier Bordes, and from Greek to English by Giacomo Donis.) Paris: Editions Galerie Enrico Navarra, 1990.

Denyse Durand-Ruel and Emmy de Martelaere, *Noirlac, Abbaye cistercienne, Vitraux de Jean-Pierre Raynaud* (foreword by Georges Duby). Brussels: Editions E.M.A., 1977.

Denyse Durand-Ruel, Yves Tissier, and Bernard Wauthier-Wurmser, *Jean-Pierre Raynaud, la Maison 1969–1987*. Paris: Editions du Regard, 1988.

Gladys Fabre, *Jean-Pierre Raynaud* (foreword by Georges Duby). Paris: Editions Hazan ("Monotypes" Collection), 1986.

Abraham Hammacher, *Jean-Pierre Raynaud*. Paris: Editions Cercle d'Art (forthcoming).

Emmy de Martelaere, *Jean-Pierre Raynaud*. Brussels: Editions E.M.A., 1975.

Catalogue Texts

Marie-Claude Beaud, preface, *Archétypes*. Exh. cat. [in French and English]. Jouy-en-Josas: Editions Fondation Cartier, 1986.

Maïten Bouisset, "Histoire d'une forme," *Archétypes*. Exh. cat. [in French and English]. Jouy-en-Josas: Editions Fondation Cartier, 1985.

Jean-François de Canchy, "Jean-Pierre Raynaud," *Exposition internationale des Arts plastiques*. Exh. cat. Belgrade: Musée d'Art moderne, 1980.

Jacques Caumont, "4,000 Pots de Raynaud au Musée d'Israël," *4,000 Pots*. Exh. cat. Jerusalem: Israel Museum, 1971.

Jean-Luc Daval, "Parce que la sculpture actuelle trouve une autre fonction," *Questions d'urbanité*. Exh. cat. Paris: Galerie Jeanne Bucher, 1986.

Georges Duby, "Demeures cisterciennes," *L'Herne*. No. 44 (published on the occasion of the exhibition "Damian + Raynaud," 1983). Paris: Editions de l'Herne, 1983.

Yona Fischer, preface, *4,000 Pots*. Exh. cat. Jerusalem: Israel Museum, 1971.

Toshio Hara, preface to exh. cat. [in English and Japanese]. Tokyo: Hara Museum of Contemporary Art, 1981.

Jan Hoet, "Jean-Pierre Raynaud ou la simplicité d'un rêve," in exh. cat. Ghent: Museum van Hedendaagse Kunst, 1978.

Pontus Hulten, "Jean-Pierre Raynaud, Pélerin du blanc," *Raynaud 1974–1978*. Exh. cat. Paris: Editions du Centre Pompidou, 1979.

Jean-François Jaeger, foreword, *Questions d'urbanité*. Exh. cat. Paris: Galerie Jeanne Bucher, 1986.

Alain Jouffroy, "Un laboratoire mental," *Les Objecteurs*. Exh. cat. Paris: Galerie Jean Larcade, 1965.

Jean de Loisy, "Jean-Pierre Raynaud, Manifeste 1984," in exh. cat. [in English]. Los Angeles: Newport Harbor Art Museum, 1984.

Bernard Marcadé, "La Montée du silence," *Noir et Blanc*. Exh. cat. Paris: Musée d'Art moderne de la Ville de Paris, 1985.

François Mathey, preface, *Rouge, Vert, Jaune, Bleu*. Exh. cat. Paris: Musée des Arts décoratifs, 1972.

Alfred Pacquement, text in exh. cat. Toyama, Japan: 1981.

Suzanne Pagé, preface, *Noir et Blanc*. Exh. cat. Paris: Musée d'Art moderne de la Ville de Paris, 1985.

Pierre Restany, ''Jean-Pierre Raynaud et la conscience de soi: un ton souverain qui a l'avant-goût de l'absolu,'' *Psycho-Objets.* Exh. cat. Paris: Galerie Mathias Fels, 1966.

————, ''Everything is just right'' [in English], in exh. cat. Tokyo: Hara Museum of Contemporary Art, 1981.

Paul Schimmel, text in exh. cat. [in English]. Los Angeles: Newport Harbor Art Museum, 1984.

Pierre Sterckx, ''Les Rouges et les Blancs,'' *Panorama sur douze ans.* Exh. cat. Brussels: Palais des Beaux-Arts, 1975.

Guy Tosatto, ''Propos autour d'un pot,'' *Archétypes.* Exh. cat. [in French and English]. Jouy-en-Josas: Editions Fondation Cartier, 1986.

Germain Viatte, ''Jean-Pierre Raynaud,'' *L'Art et la Ville. Urbanisme et art contemporain.* Paris: Editions Skira/Secrétariat général des Villes Nouvelles, 1990.

Writings, Interviews, and Interventions by Jean-Pierre Raynaud

Opening catalogue text for an exhibition touring to Stockholm, Amsterdam, Stuttgart, Paris, 1968.

Text by Jean-Pierre Raynaud and Ebbe Wraae, *Mobilia Denmark,* no. 162/163, Jan. 1969.

Conversation with Gilbert Brownstone, *Chorus,* no. 2, Apr. 1969.

Conversation with Pierre Sterckx, *Rouge, Vert, Jaune, Bleu.* Exh. cat. Paris: Musée des Arts décoratifs, 1972.

Conversation with Marian Verstraeten, *Panorama sur douze ans.* Exh. cat. Brussels: Palais des Beaux-Arts, 1975.

Introduction to *Les Forteresses du dérisoire,* a book by Jean-Claude Gautrand. Paris: Presses de la Connaissance, 1977.

Interview with Caroline Pacquement, ''Une architecture mentale,'' *Construire pour habiter.* Paris: Editions Plan Construction/L'Equerre, 1981.

Interview with Pierre Restany, ''My House, Myself,'' *Domus,* no. 624, June 1982.

————, *Cahiers de l'Herne,* no. 44, 1983.

Interview with Pierre Cabanne, ''La Quête de Jean-Pierre Raynaud,'' *Le Matin,* Mar. 1, 1985.

Interview with Pierre Descargues, on France-Culture, Mar. 18, 1985.

Interviews with Brigitte Paulino-Neto, ''Gésir entre ciel et terre, les gisants de l'abbaye de Fontevraud'' and ''La Tour prend garde,'' *Libération,* Apr. 11, 1986.

Opening catalogue text for an exhibition at Carpenter + Hochman Gallery, New York, 1986.

Intervention at Minguettes Tower in Vénissieux, presented at the colloquium ''L'Art et la Ville: Urbanisme et Art contemporain.'' Paris: Palais du Luxembourg, 1986.

Intervention, ''Y aurait-il des lieux publics interdits à l'art?,'' the Logirel press conference for the Vénissieux Minguettes Tower project, 1986.

''Conversation with,'' five half-hour broadcasts by Alberte Grynpas-Nguyen on France-Culture, 1988.

Conversation with Catherine Lawless, ''Jean-Pierre Raynaud, Container Zéro,'' *Cahiers du Musée national d'art moderne,* no. 23, Spring 1988.

Interview with Jean-Hubert Martin, ''Jean-Pierre Raynaud, traversée en solitaire,'' *Art Press,* Jan. 1990.

General Works

Papers from the colloquium ''L'Art et la Ville: Urbanisme et Art contemporain.'' Paris: Palais du Luxembourg, 1986.

Jean Clair, *Art en France, une nouvelle génération.* Paris: Le Chêne, 1972, pp. 67–68, 172.

Gérald Gassiot-Talabot, *Mythologies quotidiennes.* Exh. cat. Paris: Musée d'Art moderne de la Ville de Paris, 1964.

Catherine Millet, *L'Art contemporain en France.* Paris: Flammarion, 1987, pp. 66, 116–19, 272, 273, 278.

François Pluchart, *Pop-Art et Cie.* Paris: Editions Martin Malburet, 1971, p. 145.

Michel Ragon, *25 Ans d'art vivant.* Paris: Galilée, 1986, pp. 323–28.

Pierre Restany, ''Raynaud,'' *L'Avant-Garde au XXe siècle.* Paris: André Balland, 1969, pp. 400–402.

Werner Spies, *Rosarot von Miami Ausflüge zu Kunst und Künstlern unseres Jahrhunderts.* Munich: Prestel Verlag, 1989, pp. 195–200.

Constantin Tacou, ed. (text by Georges Duby, conversation with Pierre Restany), ''Horia Damian, Jean-Pierre Raynaud, les Symboles du lieu, l'habitation de l'homme,'' *L'Herne*, no. 44. Paris: Editions de l'Herne, 1983, pp. 212–28.

Anne Tronche, *L'Art actuel en France.* Paris: Balland, 1973, pp. 138–49, 144–145.

25 Ans d'art en France, ouvrage collectif. Paris: Larousse, 1986, pp. 265, 286, 287, 333, 342.

Documentary Films

Les Psycho-Objets de Jean-Pierre Raynaud, short feature film by Jacques Caumont, 1967.

L'Alphabet Raynaud, short feature film for television by Jacques Caumont, Claude Gallot, and Michel Pamart, 1970.

La Peur, short feature film for television by Michel Pamart and J. & J., 1973.

Les Lieux de l'art. Un espace d'esthète, report for TF-1 by Guy Olivier and Nadine Descendre, broadcast Apr. 23, 1981.

On the occasion of the exhibition ''Raynaud + Damian,'' a mid-length feature film by Françoise Merville, 1983.

A short feature film commissioned by the Fondation Cartier, by Jean-Pierre Gras and Mandarine Productions, 1985.

Désir des arts, by Pierre Daix and Pierre-André Boutang, broadcast on A2, 1985.

Lire c'est vivre, by Pierre Dumayet, about Tanizaki Janichiro's book *L'Eloge de l'ombre,* broadcast on A2, June 18, 1985.

Conversations about Mondrian, Saint-Paul-de-Vence, Maeght Foundation, 1985.

Un dessein sur l'espace, video by Gilles Pasquier, 1986.

Performances, by Michel Cardoze, broadcast on TF1, 1986.

A report on the closing of the *House* by Nicole Brisse, broadcast on TF1, 1988.

Portrait, by Pierre-André Boutang and Annie Chevallay, produced by A2 and SODAPERAGA, 1988.

Selected Press Coverage

Françoise Bataillon, ''Jean-Pierre Raynaud incognito,'' *Beaux-Arts Magazine,* Dec. 1987.

Pascal Bonafoux, ''Raynaud, La Peur,'' *Créé,* no. 20, Mar.–Apr. 1973.

Jean-Pierre Bordaz, ''Des sculptures pour le domaine de Kerguehennec,'' *Galeries Magazine,* Aug.–Sept. 1987.

Maïten Bouisset, ''Jean-Pierre Raynaud, une maison comme un tableau,'' *Art Press,* no. 45, Feb. 1981.

———, ''Jean-Pierre Raynaud, la Maison,'' *Art Press,* July 1988.

Alexandre Broniarski and Bruno Laurent, ''Jean-Pierre Raynaud, Différences et Répétitions'' and ''Glossaire,'' *Kanal magazine,* no. 4, Jan. 1990, pp. 71–75.

Jacques Caumont, ''L'Espace Raynaud, apprendre à regarder,'' *Werk* (Zurich), no. 12, Dec. 1970.

Gilberto Cavalcanti, ''Psiquicos-objatos de Raynaud tem sala na IXe Biennal de Sâo Paulo,'' *Corriento da Manhä,* Oct. 18, 1967.

———, ''Jean-Pierre Raynaud, Desejo e medo da morte,'' *Vida des Artes,* no. 5, Nov. 1975.

Jean-Luc Daval, ''Et si la sculpture n'était pas ce que l'on croit?,'' *Art Press,* no. 101, Mar. 1986.

Bruno Foucart, ''Fontevraud,'' *Beaux-Arts Magazine,* no. 27, Sept. 1985.

Catherine Francblin, ''Les Quadrillages de Jean-Pierre Raynaud,'' *Art Press,* no. 18, May–June 1975.

———, "Une tour blanche lumière," *Art Press,* no. 101, Mar. 1986.

———, "Jean-Pierre Raynaud: incandescence des extrêmes," *Art Studio,* no. 5, 1987.

Diane Germain, "Environment aus Weissen Fliesen," *Architectur & Wohnen,* June 1981.

Michael Gibson, "One Man and His Art at the Paris FIAC," *Herald Tribune,* Oct. 25, 1986.

Michel Giroud, "Jean-Pierre Raynaud, pour un art minimum," *Kanal magazine,* no. 10, 1985.

Alain Jouffroy, "La Coupure de Jean-Pierre Raynaud," *Quadrum,* no. 19.

Dorothée Lalanne, "An Artist's Music Room near Paris," *Interview,* vol. VIII, no. 11, 1978.

———, "Perceptions of a Void," *Belle,* no. 40, 1980.

Gilbert Lascault, "De quelques représentations de la Mort," *Art vivant,* Jan. 1975.

Hervé Legros, "Jean-Pierre Raynaud," *Beaux-Arts Magazine* (special FIAC edition), Oct. 1989, pp. 52–53.

Jean-Jacques Levêque, "Dans le viseur, Jean-Pierre Raynaud," *Art et Loisirs,* no. 19, 1966.

Jean de Loisy, "Jean-Pierre Raynaud," *Galeries Magazine,* Nov. 1986.

Catherine Millet, "Jean-Pierre Raynaud, un jardinier dans la ville," *Les Lettres françaises,* Feb. 5, 1969.

———, "Le rouge est mis," *Chorus,* no. 2, Apr. 1969.

———, "Vivre dans un Raynaud," *Art vivant,* Oct. 1969.

———, "Un pot de fleurs banal," *Art vivant,* no. 22, 1971.

———, "Histoire d'un pot," *Art Press,* no. 2, Feb. 1973.

Georgina Oliver, "L'Idée fixe de Jean-Pierre Raynaud," *Les Nouvelles littéraires,* no. 2675, Feb. 1979.

Alfred Pacquement, "Jean-Pierre Raynaud," *Galeries Magazine,* no. 20, Nov. 1987.

Béatrice Parent, "Jean-Pierre Raynaud à l'ARC," *Arte Factum,* May 1985.

Claude Parent, "Le Virus de Klein," *Architecture d'aujourd'hui,* Dec. 1989.

François Pluchart, "Jean-Pierre Raynaud, du Mondrian qui perturbe," *Combat,* Mar. 6, 1966.

———, "Raynaud affirme sa position internationale," *Combat,* Mar. 11, 1968.

———, "La Voie triomphale de Raynaud," *Combat,* Feb. 3, 1969.

———, "Jean-Pierre Raynaud, un Marcel Duchamp qui voit rouge," *ABC,* no. 52, Feb. 1969.

———, "Raynaud, une preuve par le Neuf," *Combat,* Jan. 26, 1970.

Jean-Louis Pradel, "Jean-Pierre Raynaud," *Créé,* Dec. 1985–Jan. 1986.

Andrée Putman, "La Maison de Jean-Pierre Raynaud," *Clefs,* no. 1, Jan. 1978.

Michel Ragon, "Jean-Pierre Raynaud," *Cimaise,* no. 112, May–Aug. 1973.

Effie Stephano, "Antiseptic Art," *Art and Artists,* no. 9, Apr. 1974.

Pierre Sterckx, "Raynaud, la mort en couleur," *Clés pour les Arts,* no. 27, 1972.

Yvon Taillandier, "En gros plan ce mois-ci, Raynaud. Pop'Art en trois dimensions," *Connaissance des Arts,* no. 166, Dec. 1965.

Mona Thomas, "Des Sculptures pour Kerguehennec," *Beaux-Arts Magazine,* Aug. 1987.

Guy Tosatto, "Jean-Pierre Raynaud, l'amateur de carreaux," *Beaux-Arts Magazine,* no. 56, Apr. 1988.

Anne Tronche, "Jean-Pierre Raynaud," *Opus International,* no. 73, 1979.

———, "Jean-Pierre Raynaud, la Maison," *Opus International,* July 1988.

Luc Vezin, "Jean-Pierre Raynaud," *Beaux-Arts Magazine* (special FIAC edition), Oct. 1986.

Photography

Shigeo Anzai, Tokyo *fig. 13*

Courtesy of Leo Castelli Gallery, New York *figs. 4, 5*

Jean-Philippe Charbonnier, Paris *fig. 7; photographic images*
 utilized in the Psycho-Objets *pls. 5, 6, 7, 15*

Jean Dubout, Paris *pl. 8*

Courtesy of the Denyse Durand-Ruel Archives, Rueil-Malmaison
 frontispiece; figs. 8, 11, 12, 14, 15, 18, 22–30, 34, 35,
 37–44; pls. 2–4, 6, 12, 13, 15–17, 19, 20, 21, 23–25, 27,
 28, 30, 32, 33

J. Hain, Paris *figs. 1, 32*

Paul Hester, Houston *fig. 3; pl. 14*

Roger Laute, Ghent *pl. 6*

David Lubarsky, *fig. 6*

R. Milon, Jerusalem *fig. 19*

André Morain, Paris *figs. 20, 21, 31, 33*

Jean-Michel Routhier, Paris *cover; pls. 1, 9–11, 18, 26, 29, 31,*
 34, 35

Deidi von Schauner, Paris *fig. 36*

Courtesy of Stedelijk Museum, Amsterdam *pl. 7*

Marc Vaux, Paris *figs. 9, 10; pl. 5*

Janet Woodard, Houston *fig. 2; pl. 22*

Design: Don Quaintance, Public Address Design, Houston

Typesetting: T$_E$XSource, Houston
 Composed in Frutiger 45 and 55

Printing: W. E. Barnett & Associates, Houston

Color separations & halftones: Color Separations, Inc., Houston

Binding: Roswell Bookbinders, Phoenix